DIGITAL PHOTOGRAPHY
Simplified®
2nd Edition

Visual™

by Rob Sheppard

WILEY

Wiley Publishing, Inc.

DIGITAL PHOTOGRAPHY SIMPLIFIED®
2ND EDITION

Published by
Wiley Publishing, Inc.
10475 Crosspoint Boulevard
Indianapolis, IN 46256

www.wiley.com

Published simultaneously in Canada

Library of Congress Control Number: 2011924147

ISBN: 978-1-118-02934-3

Manufactured in the United States of America

10 9 8 7 6 5 4 3 2 1

Trademark Acknowledgments

Contact Us

For general information on our other products and services please contact our Customer Care Department within the U.S. at 877-762-2974, outside the U.S. at 317-572-3993 or fax 317-572-4002.

For technical support please visit www.wiley.com/techsupport.

WILEY

Wiley Publishing, Inc.

Sales

Contact Wiley
at (877) 762-2974 or
fax (317) 572-4002.

Credits

Executive Editor
Jody Lefevere

Sr. Project Editor
Sarah Hellert

Technical Editor
Michael Guncheon

Copy Editor
Scott Tullis

Editorial Director
Robyn Siesky

Editorial Manager
Rosemarie Graham

Business Manager
Amy Knies

Sr. Marketing Manager
Sandy Smith

Vice President and
Executive Group Publisher
Richard Swadley

Vice President and
Executive Publisher
Barry Pruett

Project Coordinator
Patrick Redmond

Graphics and Production
Specialists
Andrea Hornberger
Jennifer Mayberry
Heather Pope
Corrie Socolovitch

Quality Control Technician
Lauren Mandelbaum

Proofreader
Kathy Simpson

Indexer
Potomac Indexing, LLC

Artists
Ana Carrillo
Jill A. Proll
Mark Pinto

About the Author

Rob Sheppard is the author/photographer of over 30 photography books, a well-known speaker and workshop leader, and editor-at-large for the prestigious *Outdoor Photographer* magazine. As author/photographer, Sheppard has written hundreds of articles about digital photography, plus books ranging from guides to photography such as *Digital Photography: Top 100 Simplified Tips & Tricks* to books about Photoshop Elements and Lightroom including *Adobe Photoshop Lightroom 2 for Digital Photographers Only* and *Photoshop Elements 9: Top 100 Simplified Tips & Tricks*. His website is at www.robsheppardphoto.com and his blog is at www.natureandphotography.com.

Author's Acknowledgments

First, I have to thank all of the photographers who have been in my workshops and classes because it is their questions and their responses to class work that help me better understand what photographers really need to know about digital photography. To do this book right for photographers requires a lot of folks doing work along the way. The folks at Wiley are great both for their work in creating books like this and their work in helping make the book the best it can be. I really appreciate all the work that editor Sarah Hellert did along with her associates in helping keep this book clear and understandable for the reader. I also thank my terrific wife of 30 years who keeps me grounded and focused while I work on my books. I thank the people at Werner Publications, my old home, where I was editor of *Outdoor Photographer* for 12 years and helped start *PCPhoto* (now *Digital Photo*) magazine — I thank them for their continued support so I can stay on top of changes in the industry. And I thank Rick Sammon for his support and inspiration in doing photography books.

How to Use This Book

Who This Book Is For

This book is for the reader who has never used this particular technology or software application. It is also for readers who want to expand their knowledge.

The Conventions in This Book

① Steps

This book uses a step-by-step format to guide you easily through each task. Numbered steps are actions you must do; bulleted steps clarify a point, step, or optional feature; and indented steps give you the result.

② Notes

Notes give additional information — special conditions that may occur during an operation, a situation that you want to avoid, or a cross reference to a related area of the book.

③ Icons and Buttons

Icons and buttons show you exactly what you need to click to perform a step.

④ Simplify It

Simplify It sections offer additional information, including warnings and shortcuts.

⑤ Bold

Bold type shows command names, options, and text or numbers you must type.

⑥ Italics

Italic type introduces and defines a new term.

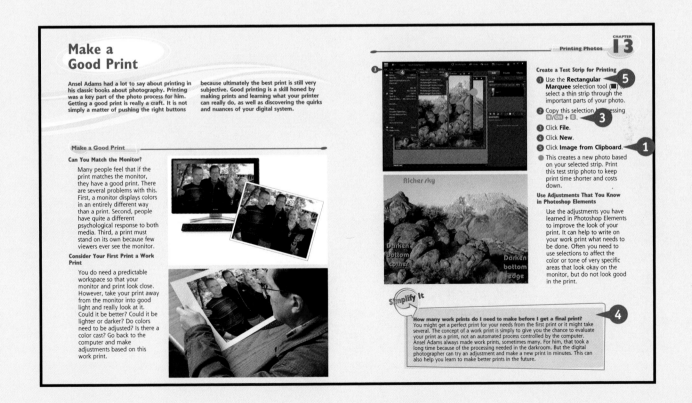

Table of Contents

3

Using Light to Your Advantage

4

Understanding Exposure and White Balance

Table of Contents

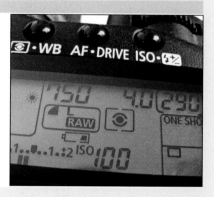

Table of Contents

11

Basic Adjustments with Photoshop Elements

12

Additional Controls with Photoshop Elements

13

Printing Photos

14

Basic Video Editing with Premiere Elements

Chapter 1

Getting Ready to Take Pictures

You bought your camera and are excited to use it. The manufacturer set up your camera to be used by everyone, but that usually means not perfect for you. The default settings of your camera are designed for the needs of the average photographer; as a result, they are not optimized for anyone who wants to take better photographs. No matter what camera you have, you can customize it so that it works better for you.

You can set up your camera right to support your picture taking. This chapter describes the basics of getting ready to take great pictures with your camera.

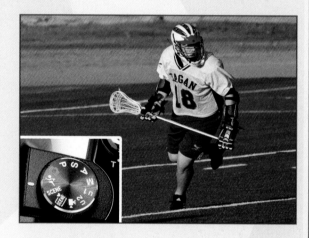

Set Up Your LCD for Optimum Use

The LCD screen on the back of your camera is a window into your photography. It shows what you are going to get in your photograph, a view more accurate than the viewfinder. But in order to get the most from your LCD, you need to use the camera's menus to make some choices about how it works. You want to be sure it is helping you, not holding you back. Here are some tips in setting up your camera for the best use of your LCD.

Review Time

After you take the picture, the actual image shows up on most LCDs. This image review gives you a quick look at what your photo looks like. For example, you can quickly look to see that it is sharp, and that your subject's eyes are open. You know immediately if your photo is what you want or if you need to take another photo.

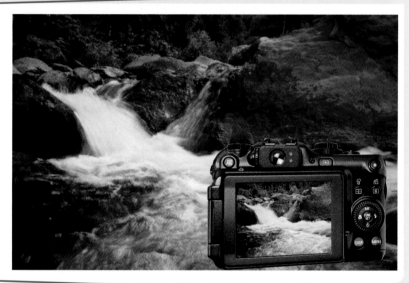

Set Review Time

On most cameras you can set review time between about 2 and 10 seconds in the camera or setup menus. Short times are not of much value because you really cannot evaluate much of what is in the picture. Try 8 to 10 seconds. Once you have seen enough, press the shutter release lightly, and the review goes away. If the time is still too short, you simply press your playback button for a longer view.

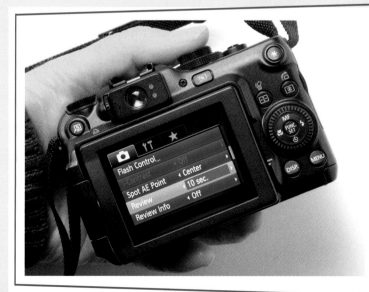

Auto Rotate

Most digital cameras today automatically rotate a vertical picture so that it shows up vertically in the LCD when you hold the camera horizontally. Unfortunately, a vertical picture does not fill the horizontal space and uses the LCD inefficiently. Get the most from your LCD and get the largest picture possible by setting the camera so that it does not auto rotate vertical pictures if possible. The Auto Rotate setting is usually in the playback or setup menus.

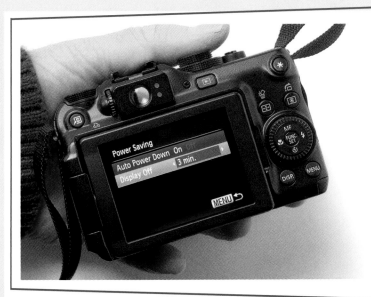

Camera Sleep Time (Auto Power Down)

A frustrating thing for digital photographers is to try to take a picture and find that the camera has gone to sleep. Most digital cameras have the auto power-down time set too early. This setting is usually in the setup menu, and a good setting would be 2 to 4 minutes for most people. You can set this time longer, but then you could be using your battery more than you want to.

Viewfinder or LCD — Which to Use?

Digital SLRs (digital single lens reflex, or DSLR) have both a viewfinder and an LCD. An LCD used to focus and frame your subject is called a live view LCD on a digital SLR. Viewfinders on true digital SLRs are optical, but some digital cameras have an EVF (short for electronic viewfinder). A viewfinder works only when you hold it up to your eye. Most people use the LCD when possible because it seems so natural to do. Both have some distinct advantages. Knowing the possibilities of a viewfinder can help you use your camera more effectively. Small digital cameras now usually have only an LCD, so this question does not apply.

Use the Viewfinder in Bright Light

LCDs can be hard to see in bright light, especially when bright subjects are in front of you. Because an optical or electronic viewfinder limits extraneous light, and your head blocks more light, a viewfinder allows you to see the subject better for framing in those conditions.

Use the LCD Inside

The LCD is ideal for shooting indoors. It has a consistent brightness, even if the light is low, which makes it easier to use than a viewfinder in those conditions. It also shows you if your exposure and white balance are correct so that you can get the best-looking image.

Use the Viewfinder for Moving Subjects

Movement can be hard to follow with an LCD held away from your face. This is where a viewfinder comes in handy. Because you have to have the camera up to your eyes to use a viewfinder, following movement becomes easier (the camera simply follows your gaze). Distracting movement around the camera and LCD is blocked from view and not seen. Optical viewfinders are especially good for sports action.

Use the LCD for Close Shooting

Your LCD is showing you exactly what the lens is seeing on your camera. You can see exactly what is or is not focused. You can even magnify the view in the LCD on most digital SLRs so you can get even more accurate focus. With compact digital cameras, the viewfinder is not made for close shooting and gives inaccurate framing.

Choose a Resolution and File Type

Your camera comes with a certain resolution, such as 10 or 15 megapixels. This resolution strongly affects the capabilities of the sensor and may affect the price of your camera. Your camera also comes with a default setting for the file type and compression that may or may not be best for you. Understanding a little about resolution and image files ensures that you make the right choices for the highest-quality photos. This also means you get your money's worth from your camera and sensor.

Find Your Settings

Resolution and file type are settings that affect image size and quality. They are usually found in the camera operation section of the menus for your camera. Unfortunately, camera manufacturers have not made the icons for these settings consistent, and so you may have to check your manual.

MENU Setting the Image-recording Quality ▬

You can select the pixel count and the image quality. Six JPEG recording quality settings are provided: ◢L/◣L/◢M/◣M/◢S/◣S. Three RAW recording quality settings are provided: RAW, M RAW, and S RAW. RAW images must be processed with the provided software (p.60).

1 Select [Quality].
● Under the [◘˙] tab, select [**Quality**], then press <SET>.

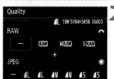

2 Select the image-recording quality.
● To select a RAW setting, turn the <🗇> dial. To select a JPEG setting, turn the <◯> dial.
● On the upper right, the "***M (megapixels) **** x ****" number indicates the recorded pixel count, and [***] is the number of possible shots (displayed up to 999).
● Press <SET> to set it.

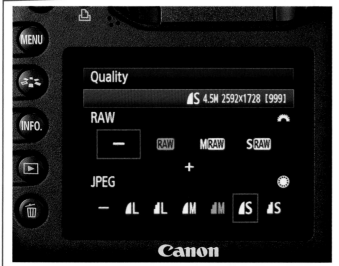

Use Your Megapixels

A common way of showing image size is L, M, and S (for large, medium, and small resolution). Large uses the full size of your camera's sensor, giving you the megapixels you paid for. Use it. Only use the smaller sizes if you really have to get small photos, such as for a website, and you are sure that you will never need a large photo.

Choose JPEG with High Quality

The default image type for most digital cameras is JPEG shot at medium compression or *quality* (quality refers to how the image is compressed for size). For optimum JPEG images, choose the highest-quality compression, such as Superfine or the selection with the smooth curve to the left of L. This makes files a little larger but not much, and memory card prices are low today, so get one to handle larger file sizes.

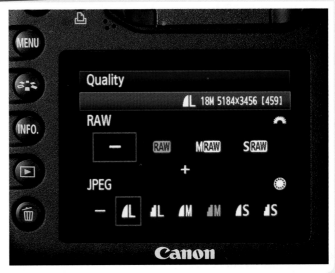

What about RAW?

Some compact digital cameras and all digital SLRs include an image type called RAW. This is a special format that saves far more tonal and color information from the sensor than JPEG offers. It is very useful for photographers who want to do extensive processing on their images in the computer. However, it does not have more detail than a JPEG file (that is dependent on megapixels).

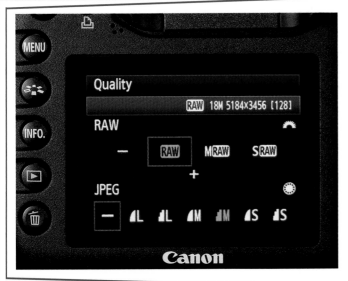

Choose a Memory Card

Your camera is built to hold a certain type of memory card. A memory card stores your pictures, and you save photos to it or erase photos from it. These cards come in a variety of types such as CompactFlash or SD cards. You cannot decide what type to use — you must use the specific type your camera needs. However, you do need to decide how large a card to get and whether a certain speed will affect your choice of card. For example, you will find that the highest capacity and fastest SD cards, such as SDHC or SDXC cards, only work in newer cameras. Most cameras have slots for only one card, though a few digital SLRs have slots for two.

Memory Card Types

You should know your memory card type so that you can recognize it in a store and be sure you have the right type. Each card type is quite different in size and shape. Your manual will tell you what kind to buy. If you do not remember what card is in your camera, open the door to the memory card slot on your camera, and take out the memory card to see exactly what it looks like (be sure the camera is off when you do this).

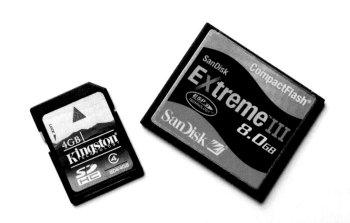

Choose Memory Capacity

Memory cards have become less expensive for more capacity. 2GB cards can be found easily at very affordable prices. The larger the capacity, the greater the number of images you can store. Capacity is key with higher-megapixel cameras, and especially for RAW files. Try a 2–4GB card if you shoot JPEG with a 10- to 15-megapixel camera. Go to 4–8GB for RAW files. If you plan on recording video with your camera, select an 8–16GB card.

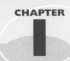
How Important Is Memory Card Speed?

You will often see memory cards listed with speeds 100X, 133X, and higher. Or you might see cards with a MB/second rating, such as 15MB/sec. This does not speed up your camera. It affects how fast images are recorded to a memory card from the camera's memory buffer. Keep in mind that not all cameras support high speeds, but high speeds are needed for shooting video. Speed can also affect how fast you can download images to your computer.

Download from a Memory Card

A simple way of downloading photos is to use your camera and the cable that came with it. A better way is to get a memory card reader. A memory card reader is usually faster, takes up little space on your desk or computer, and never has problems with battery power (if your camera loses power while downloading, you can lose your photos).

Hold the Camera for Sharpness

Digital cameras are capable of truly excellent sharpness. Yet all too often photographers are disappointed by blurry photos. The photos look unsharp, and people often blame "cheap cameras." Yet, the number one cause of blurriness is camera movement during exposure. How you hold the camera and release the shutter can determine whether you capture a sharp or blurry photo. This is especially noticeable if you want to enlarge the image in a big print.

Camera Movement Causes Blurry Photos

When a camera is handheld, it can move slightly while the camera is taking the picture. As shutter speeds get slower, this means blur in your photo, and sharpness that is much less than your camera is capable of. Even if the blur is not obvious, it can still be there, degrading the contrast of the image. No amount of work on the computer can make these images truly sharp.

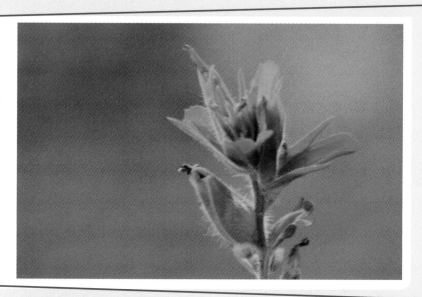

Support the Camera Well

Support your camera to minimize camera movement. With a digital SLR, put your left hand, palm up, under the lens, with your right hand gripping the side securely. With compact cameras, keep both hands gripping the sides solidly — no one-handed shooting! Then keep your elbows in to the side of your chest as you photograph, in order to keep arm movement to a minimum.

Squeeze the Shutter

Holding the camera securely does not help if you punch the shutter button. Put your finger on the shutter button, and then squeeze your finger down in a smooth motion to push the button and take a picture. Keep your finger depressed as the shutter goes off, and then release it gently.

Turn Your Car Off for Sharpness

Go to any national park, and you will see people driving along, photographing from cars, bracing their arms against the frame of an open window. A moving car, combined with the vibration from the motor, always causes problems with camera movement and blurry photos. For optimum sharpness, stop the car and turn off the engine. At the minimum, avoid leaning against the car frame if the car is running.

Choose a
Program Mode

Digital cameras are programmed to offer you choices on how the camera deals with a particular subject or scene. These programmed ways of operating the camera offer you options that affect how you can get the best pictures of a particular subject or scene. They are often set up for specific subjects or types of scenes so that the camera can be quickly prepared for them. By understanding a bit about them, you can quickly choose what works best for you.

Exposure Mode Choices

Cameras have to be set for a proper exposure. That includes both a shutter speed, which affects action, and an aperture or f-stop, which affects depth of field (sharpness in depth). These settings also affect how much light comes through the camera. Exposure modes change how these controls are chosen — that is, how much the camera's internal electronics do and how much you control.

Program, Aperture Priority, and Shutter Speed Priority

All digital SLRs and many small digital cameras include the modes P for Program, A or Av for Aperture Priority, and S or Tv for Shutter Speed Priority exposure. The camera chooses both shutter speed and aperture in P, making it good for quick shots. In A, you choose an aperture for depth of field, and the camera sets the shutter speed. In S, you choose a shutter speed, and the camera sets the appropriate aperture or f-stop. You can learn more about choosing shutter speeds and f-stops in Chapter 5.

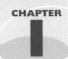
Program Scene Modes

Many popular cameras include special program modes designed to make decisions easier about setting up a camera for specific subjects. You will find options such as Landscape, which affects exposure, color, ISO setting, and white balance for scenic pictures; Portrait, which affects the same things for close-up shots of people; and Sports, which is designed to optimize the camera for action.

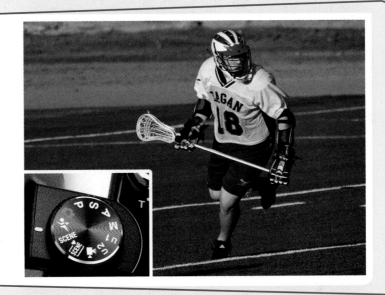

Do You Need Manual?

Manual is a mode where you set all exposure parameters yourself. Many photographers never need it, but it is helpful when conditions seem to fool all the other modes. In Manual mode, you can set shutter speed and f-stop based on how the meter works in your camera, take a picture, and then check your exposure in the LCD. If the exposure is not what you need from a scene, you can then change the shutter speed or f-stop until it is right.

Using Your Camera's Autofocus

Autofocus, or AF, is a great innovation. The camera works with the lens to determine where the lens needs to focus. AF helps your camera and lens find the right things to make sharp in your scene. That makes it easy to photograph quickly, but AF can also focus in the wrong places. However, you can learn how to control it. A few simple techniques will help you ensure that the autofocus is finding the right part of your scene to focus on.

Focus Points Are Important

One of the most annoying things for a photographer is to have a nice picture where the focus is in the wrong place. For example, you have a great shot of grandma, but she is not sharp, though the tree behind her is. Or your beautiful flower stays blurred whereas the woodchip mulch behind it is sharp. Learn to look quickly at a scene so that you know the most important points that must be sharp.

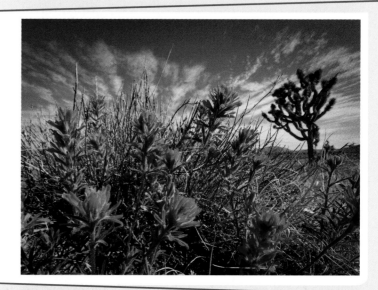

Lock Focus on Your Subject

Once you know what has to be sharp, set your camera on single-shot AF and then point your camera at the key part of your subject that must be sharp. Next, press your shutter button slightly to lock focus. The camera usually beeps or gives some other indicator of focus. While still pressing the shutter button, quickly move the camera to frame your shot properly, and then take the picture by pressing the shutter all the way. Some cameras also have separate focus lock buttons.

Use Continuous Autofocus for Action

If you are photographing action or a sporting event such as a kids' soccer game, you usually cannot lock focus because of the continuous movement. Change your camera to continuous AF if it has that choice. Now the camera continuously focuses as you shoot the action. Sometimes the action is too fast for it to keep up, so you get out-of-focus shots, but mostly it keeps finding the right focus as the action progresses.

Start Autofocus Early

Any AF system needs some time, however brief, to examine the scene, determine the focus point, and focus the lens. If you wait until you need that focus, especially with a moving subject, then you will often miss the shot because of this time delay. Start your autofocus early, before you need it, by lightly pressing your shutter button enough to get AF going, but not enough to trip the shutter.

Chapter 2

Taking a Better Picture through Composition

Better photos start with *composition* — the way you arrange the subject, background, and other parts of a photograph within the image area. Sometimes this is referred to as framing the subject or scene. Any composition is based on your decisions on what to include in the photograph, what to keep out, and how to place your subject in the scene.

What makes a composition work? This chapter answers these questions, by showing you how to get better compositions in your photographs. You learn about some specific techniques that you can use with your camera and on your subjects.

Simple Pictures Work Best

Beginning photographers often try to get everything into one photograph. Instead of one goal and one subject for one photograph, they try to satisfy many goals in a single image. This can lead to busy, confusing photos that are not very satisfying to the photographer or a viewer of the image. By looking to make photographs simple and direct, and by more clearly knowing what you want from a photo, you can quickly create more appealing photos.

Decide What Your Subject Really Is

Does this seem like an obvious point? Although it is important, too many photographers do not really consider it. You need to know what your subject really is so that you can be sure your composition complements it and never fights with it. You will also run into trouble if you include multiple subjects in a photograph, because this can confuse your viewer.

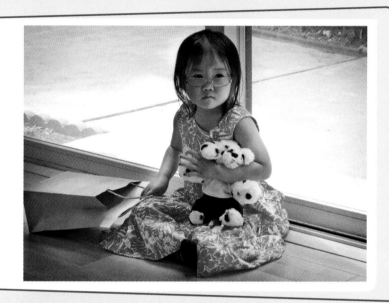

Make Your Subject the Star

Your subject is important, so be sure it has a starring role in your photograph. Your subject should never be a secondary part of a photo. Keep the photo simple in content so that the viewer can immediately see the subject and the scene you want to highlight. Do not make your viewers struggle to see the subject in a photograph that includes too much of the world around it. Do not try to include too much.

Watch Out for Distractions

Distractions take the viewer's eye away from your subject. Keep them out of your photograph. Avoid really bright spots in the background, especially high in the picture, because they always attract the viewer's eye. Watch out for signs — your viewers will always try to read them. Be careful of high-contrast details that appear away from your subject because they draw the eye from your subject.

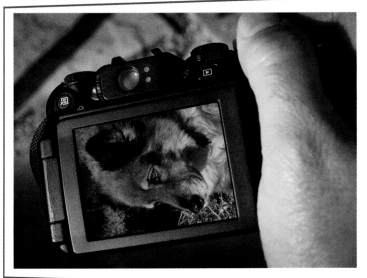

Use Your LCD Review

That LCD on the back of your camera is such a wonderful tool. It really helps with composition. Think of it as a little photograph. Do you like that photograph? Is the subject the star of that photograph? Are there distractions in the image area taking your eye away from the subject? Review your shot and be sure you have something that clearly favors the subject.

Get Close to Your Subject

Your subject should be the star of your photos, and one way to make that happen is to be sure you are close enough to the subject that it appears at a good size in your viewfinder. All too often, photographers step back from their subjects to get everything in, when they should, in fact, be stepping closer to get the best shot possible of that subject. Occasionally, it looks good to have a small subject with a huge scene, but most of the time, a large subject in the frame looks best.

Watch the Space around Your Subject

Photographers often focus so hard on the subject that they do not really see the rest of the photograph. A way to force yourself to see the whole image is to look at the space around your subject when you review the shot in the LCD. That tells you a lot about space and subjects and helps you refine your shot.

 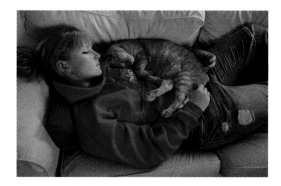

Take a Step Closer

A great technique to try is to frame up your photo to get what you think is a good shot, and then take a step closer while keeping the zoom untouched. Frame up and take the picture. That extra step often makes a more dynamic, interesting photo. It also forces you to deal with the subject differently within the image frame.

More Is Not Always Better

As noted in the last section, confusion as to what is really your subject can cause problems with your composition. This confusion often comes when photographers try to include more and more in their image. Creating an interesting image with a lot of details is possible, but it is a lot easier to create a strong photo by simplifying what you include in your photograph.

Experiment with Your Zoom

A great way of encouraging you to make a photo simple and direct is to challenge yourself with this exercise. Set your zoom to its strongest telephoto position, and then go out and take ten different photos at that zoom position, never changing it to make a wider shot. This makes your photos look like you are close to your subject, even if you are not.

Find a Foreground

The foreground of your photo can make the difference between success and failure for a picture. The foreground is simply the area in front of your subject that your camera sees. Often photographers simply focus so much on the subject that they do not even see the problems and challenges of the foreground. Foregrounds can complement a subject or they can distract and detract from it. You always have the choice.

Use the Foreground for Depth

When you have a strong foreground to your photo, the image looks deeper. A photograph is a flat, two-dimensional object that tries to reflect a three-dimensional world. A good foreground creates and defines a relationship from close to far so that your composition has a feeling of three dimensions.

Look for a Frame

A quick and easy way of using your foreground is to look for a frame that controls what the viewer sees of the subject and background. This can be as simple as an interesting tree branch across the top of the photo. Or it can be an opening in a building or a rock formation that gives a view of your scene.

Get Close and Shoot through a Foreground

You cannot always get a sharp foreground. You can use that challenge as an opportunity for a better photo. Get up close to that foreground and shoot through it, almost like you would shoot through a frame, but use a telephoto setting on your zoom to make the foreground soft and not sharp.

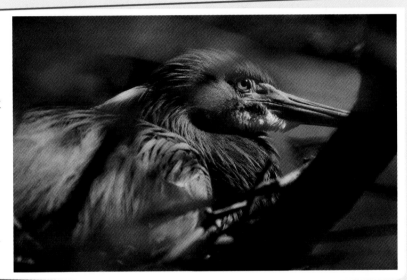

Use a Wide-Angle View and Tilt Down

Often, photographers shoot a scene with a wide-angle lens to get it all in, and then put the horizon right in the middle of the picture. Try instead to tilt the camera down so that you see the foreground better, and then move to find something interesting in the foreground that you can include in your photo.

Watch Your Background

Just like the foreground, the background can make or break a picture. Often photographers pay so much attention to the subject itself that they forget to look at what is behind the subject. This is especially a problem with a digital SLR because the background often looks out of focus when you look through the lens, and yet it changes with the actual taking of the picture. But this happens with any camera when the photographer sees only the subject.

Distracting Backgrounds Hurt Your Subject

A constant challenge that photographers face is avoiding backgrounds that distract from or fight with their subject. Watch what is happening in a background and move your camera position to avoid things like "hot spots" of light or bright colors.

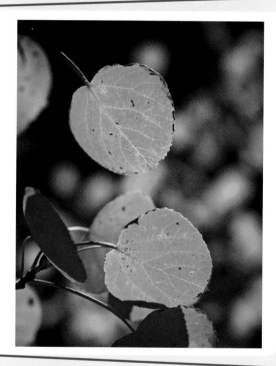

Simplify a Background

A great way to keep a background subordinate to your subject is to find an angle to your subject that keeps the background behind it simple. It is hard for a simple background to distract from your subject. Without a lot of stuff behind your subject, the viewer of your picture will more clearly see your subject.

Contrast Your Subject with the Background

Another way to ensure that your subject stands out is to look for contrasts between it and the background. For example, if your subject is light, see if you can get something dark behind it, such as a large, dark shadow, or find a color distinctly different than your subject.

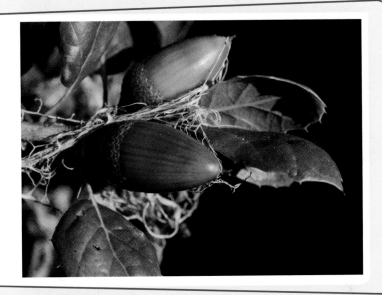

Place Your Background

Even if you cannot get close to your subject, you can often make it stand out by placing your background carefully behind it. Find a dark area, and then move so that a brighter subject is in front of it. Or find a strong color and then move so that it sits behind your subject.

The Rule of Thirds

Over the years, artists and photographers have developed compositional "rules" to make good composition easier. A good easy-to-use one is the Rule of Thirds. This is so popular that some cameras can even display superimposed lines over the scene that match the Rule of Thirds.

You do not always have to use the idea of a Rule of Thirds, though, because your subjects in the real world do not always fit in it. However, it is a good place to start for placing things in a photo.

Divide a Photo into Horizontal Thirds

In your mind, draw imaginary horizontal lines across the image in your viewfinder or on your LCD that divide the photo into thirds. Use these lines to position your horizon or any other strong, horizontal line. This helps get your horizon out of the center of the image, which is a poor place for most horizons.

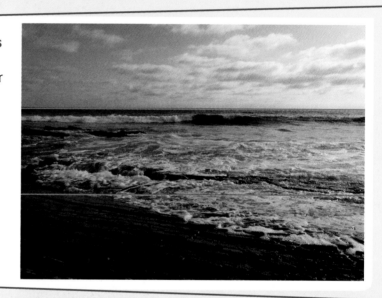

Divide a Photo into Vertical Thirds

Again, draw imaginary lines across the image in your viewfinder or on your LCD, but now use vertical lines that divide the photo into thirds. Use these lines to position strong vertical elements, such as trees or tall buildings. These are effective compositional places for this type of subject matter.

Use the Intersections

If you consider both the horizontal and vertical lines at once, you find that you have four points where the lines intersect. These are great locations for your subject. These positions create interesting visual relationships with the rest of the photo, so you need to look at the rest of the photo beyond just placing your subject. That "rest" of the photo affects what the whole image looks like.

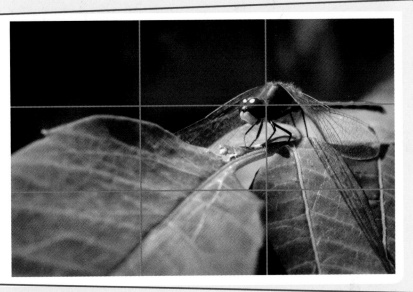

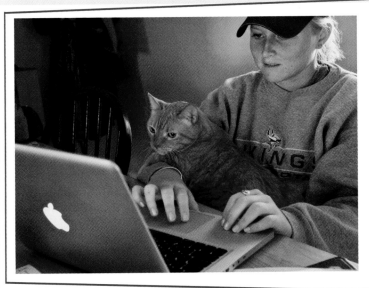

Rule or Guideline

The real world, or your view of the world, does not always fit the Rule of Thirds, in which case you should not force the composition into thirds. However, it can be a guide for how you place your picture's elements within the photo. It will especially help you get some variety in your pictures so that your subject is not always in the center.

When Centered Is Good

You will get advice from seasoned photographers to keep your subject out of the center of the picture. This is certainly a reason for the Rule of Thirds and it is good advice — most of the time. However, if you always keep the subject out of the center, you limit your options for composition. If you make a deliberate decision to either keep the subject in the center or not, then you are more likely to find a good place for the subject in your composition.

Create a Bold Center

Some subjects have a strong center with radiating lines that all point to the center. You can use that center in a composition by putting it in the center of your picture top to bottom, left to right, or both, and then getting in close. You need to get in close enough so that all extraneous details that do not relate to the center and its supporting lines are kept out of the photograph.

Find a Balanced Composition

You will find some subjects that simply have a balance between top and bottom or side to side. Find a way to emphasize that balance by putting a center found in the subject in the middle of the photo. For example, if the subject is balanced left and right, center the subject in the photo the same way, left to right.

Balance Night and Day

There is a point in the sunset where the sun is right at the horizon. This is truly a balance point between night and day. You can put the horizon and the sun right in the middle of the picture if the top and bottom have detail to support the composition, such as a water scene. Otherwise, put the sun in the middle from left to right, but at the bottom of the photo so that the sky is emphasized.

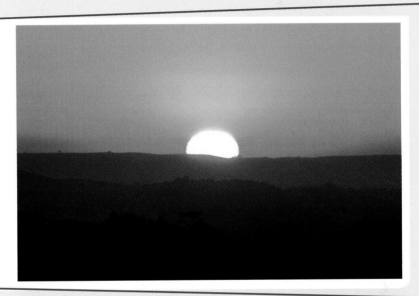

Look for Patterns

Patterns that work from the center can be fascinating for a composition. Sometimes the subject has naturally concentric patterns, such as a snail's shell, but other times those forms come from the way you line up objects in a scene. These can all make fascinating photographs.

Where Heads Belong

Pictures of people come in an almost infinite variety and combination of friends, family, or just everyday people on the street. Portraits capture a person's essence or character, whereas candid shots from events or parties display more of real life. Whether your photos are single-person shots or show entire families or even sports teams, people as subjects are one of the most common reasons for taking pictures. You can get better people pictures by paying attention to where you place their heads.

Keep Headroom Tight

You will often see people pictures with the heads centered in the photo and a big space over their heads — too much headroom. Unless there is a good reason for putting space over a head (such as an important part of the background being there), keep the space tight and to a minimum, but without touching the head to the top of the image area.

Crop a Head to Show a Face

You may notice that a dramatic effect often used by television news is to crop into the head of someone being interviewed so that you cannot see the top of his head. This forces the viewer to look at the person's face, expression, and eyes, rather than just seeing an outline of the head.

Keep Group Heads Close to the Top

Parents and other relatives love to get photos of their families all together. Also, parents of kids playing sports rush out to find and photograph their kids with the whole team. But then they put a lot of headroom above the top of the back row or above the tallest person, shoving the whole group into the bottom of the photo. A better approach is to tilt the camera down so that the tallest heads are close to the top of the picture.

Center a Close Portrait Left and Right

When you get in close to a subject, you will often find that it looks best when balanced left and right. You do want to keep headroom tight at the top, regardless of whether the subject is a person, a cat, or even a flower. By balancing the photo left and right, you make sure the viewer really looks at the subject rather than the composition.

Watch Your Edges

It is easy to get so caught up photographing your subject and making sure it looks right that you forget to look at the edges of the picture. However, those edges can be extremely important and affect how viewers look at and perceive your photograph. Sometimes those edges can cause major problems when they include elements that do not belong in the image. You need to have edges that work with, not against, your photo.

Scan the Edges for Distractions

Distractions, such as branches, feet, hoses, and cords, often creep in uninvited along the edges of a photograph and call attention to their presence. Check edges regularly, including in playback on the LCD, and watch for distractions that need to be kept out of the photo.

Create a Photo with All Detail on the Edges

One way to really learn to watch the edges is to actually do a little exercise with the edges of the photograph. Try giving yourself an assignment to take ten pictures that not only keep the subject out of the center of the photo, but also have important detail only along the edges of the picture.

Lead the Viewer in from the Edge

You will often find scenes that you can compose with something coming from the edge of the photo, such as a stream, that progresses into the image area in such a way that it draws the viewer's eye in as well. Curving lines can be particularly effective and pleasing when they do this.

Deliberately Crop a Subject at the Edge

The French impressionist painter Degas was famous for his paintings of ballerinas, where he deliberately cut off figures right at the edge of the frame. Photographers often get subjects touching the edge inadvertently. That creates a weak composition. Strength can come from really looking and thinking about an edge and how it affects the scene.

Shoot Verticals and Horizontals

Cameras are made to shoot horizontally. Many cameras are even awkward to hold any other way. So the fact that verticals are not as easy to do, and therefore, of course, not done as often, is no surprise. Yet the world is both vertical and horizontal, so why should your photographs not reflect that? In addition, when you have both vertical and horizontal photographs of your subject, you know that you are looking for fresh and better ways of capturing that subject.

Experiment with Holding a Camera Vertically

In order to get vertical photographs, you have to be comfortable with holding your camera vertically. If it feels too awkward, you will not do it. Try turning the camera vertical and think about how it feels. Discover the best way for you to hold the camera vertically. Find the easiest way for you to reach the shutter, even if you have to use a different finger than normal.

Shoot Vertical Subjects Vertically

This may seem obvious, but cameras have such a strong horizontal orientation that many photographers just give in to that orientation, no matter what the subject looks like. Just remember to think vertically with vertical subjects.

Shoot Vertical Subjects Horizontally

Once you start shooting vertically, though, it is easy to forget to do horizontal shots for vertical subjects. This is important because your photos start to look a bit boring if you shoot all horizontal subjects horizontally and all vertical subjects vertically. The point is to mix it up a bit, but to be sure that verticals get both horizontal and vertical coverage.

Shoot Horizontal Subjects Vertically

Something that very few photographers do is shoot horizontal subjects vertically. It can be hard to do, but it can also create interesting photos that are very graphic and even abstract. When you start trying to place horizontal subjects in a vertical photo, you have truly arrived at looking for both vertical and horizontal compositions.

Using Light to Your Advantage

Light — it is what makes photography work. Without light of some sort, you cannot take pictures. But light is not some absolute, unchanging thing. Light can be strong or weak, colorful or dull, contrasty or flat. Light changes as you change your angle to a subject, or change the time of day that you shoot.

In this chapter, you learn to literally see the light on your subject and how it appears in a photograph. You learn what helps and hurts a picture so that you can control that light and take better photographs. Light can be a villain, but with a little study, you can turn it into a constant friend.

See the Light

Beginning photographers concentrate so much on the subject that they do not always see other things, such as the light on the subject and its surroundings. That light can be more important than the subject itself because the wrong light can make the subject almost disappear from view, whereas the right light can make that subject the star of your picture. Start "seeing the light" and you will find immediately that your photos get better.

Where Is the Light?

Start by forcing yourself to go beyond putting the subject into your picture. Make yourself look at the light. Where is the bright light? Where are the dark areas? Is the light where it needs to be in order to make your subject look its best?

Watch Both Subject and Background Light

You saw how important the background was in the last chapter. It continues to be important with light. A problem often arises when the light on the background wants to compete with the subject. Always remember that a viewer's eyes are attracted to bright areas in a background.

Notice Highlights and Shadows

Light is about bright areas and shadows. You must look at both types of light on the subject and background. Bright lights can help a subject, or they can create harsh contrast where it is unwanted. Shadows can set off a subject, or they can add unwanted contrast.

Use Your LCD Review

You probably have noticed how important that LCD is for getting better photos. The LCD can really help you see the light. Our eyes see light differently than the camera. Therefore, you can get fooled if you are looking only at the subject as you photograph it. Check that LCD review to see what the light really looks like in your picture.

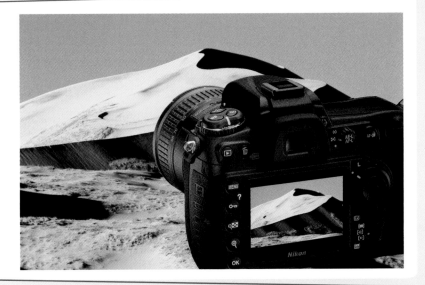

Shadows Are Important

Shadows are critical to a good photograph, and they appear only with the light. Shadows can be gentle and open in their tonalities so that detail appears throughout them. They can also be hard-edged and dramatic while hiding detail within them. Either way can be both good and bad for your subject, depending on what the shadows actually do and where they fall. The worst thing is to have shadows make your subject less visible in a photograph. Seeing the light also means seeing the shadows.

Shadows Are an Important Part of Light

Photographers just learning about light can concentrate so much on seeing the light that they do not see the shadows. Yet shadows are as much a part of any light as the bright areas in a photo. Start looking at your subject in terms of both the light and shade, and how both can either make or break a picture.

Shadows Can Make Your Subject Stand Out

Very often, you can move around your subject so that shadows appear in the background and make that subject stand out. Shadows usually give a tonal or brightness contrast that helps the viewer of your picture see the subject better. Even a small piece of shadow behind a bright spot of your subject may help.

Shadows Can Be Distracting

When shadows fall across your subject, watch out. The photo can become unusable. This is one place where an overemphasis on the subject can really hurt your photo. If you see the subject and photograph what you "see," it is easy to miss how cross shadows or just shadows in the wrong places can make a good-looking subject look bad.

Shadows Can Make Interesting Photographs

Shadows themselves can be a great subject. Shadows make interesting patterns all around us, and a photo of those patterns can make a wonderful image. Look for those shadows and how they play across the ground or on the side of a building. Then take your photograph up close, emphasizing those shadows.

Light Can Hurt Your Photos (What to Avoid)

This chapter has already given you several ideas about problem light and shadows. But if you do not pay attention to some distinct light challenges, you will not get the best photos that you and your camera are capable of. There are definitely some lighting conditions to avoid. The camera has limitations as to what it can and cannot do.

Beware of Harsh Midday Sun

That bright midday sun can be a real problem for photographers. It is a time of day when everyone is out, but the light is often filled with too much contrast between shadows and highlights. The shadows are also often in the wrong places for the subject to look its best. Sometimes you just cannot get a good photo at this time.

Watch Out for Hot Spots

The camera cannot handle the extremes of light that are common both indoors and out. Yet people can see beyond those extremes and see detail that a camera cannot. Do not get fooled by bright spots of light that end up as hot spots in your photograph. Because the camera cannot capture them the way your eyes do, look for a different composition that does not include them.

Avoid Shadows That Cover Good Parts

A severe problem with light is a hard-edged shadow cutting across your subject in an inappropriate manner. That shadow can be very disruptive and distracting. In harsh light, these shadows can make it hard to actually see your subject clearly.

Avoid Light That Is Away from the Star

If you ever go to a stage show, you immediately see how the actors get the good light. The actors are the stars of the show — not the stagehands, not the orchestra, not the audience — and so the light favors them. This idea fits photography just as well. Watch your subject so that it gets the important light.

Low Front Light Can Be Beautiful

Front light is light hitting the front of your subject, as seen from your camera position. It is definitely a light with many qualities, both good and bad. It is the light that people used to say you always had to have: light coming over your shoulder and hitting the subject.

Today you hear a lot of photographers say that you should always avoid front light. This light is arbitrarily neither good nor bad, but it can be useful to understand.

Front Light Can Be Boring

Front light is often boring because it has few shadows. The shadows fall away from the subject toward the background. Midday front light is generally too high to be an attractive light. It creates small, harsh shadows (including under eyes or a hat brim) and flat light elsewhere.

Low Front Light Is Dramatic

When the light gets low, it is less harsh than midday light and has a rich quality to its highlights and shadows. It can become like a low spotlight at a theater and get quite dramatic when a dramatic difference in light exists from foreground to background.

Low Front Light Is Colorful

As the sun gets lower and approaches the horizon, it warms up and adds great color to a scene. This can be a very beautiful light, and you often see it used for a romantic look in Hollywood films. It is an easy light to shoot in, although it can be hard on a subject's eyes.

Low Front Light for People

A low front light can be very attractive for people. This type of light gets into the shadows on their faces, making eyes bright and filling in wrinkles. You may find that your subjects have trouble looking into the light. Have them look down as you get ready, and then up and into the camera just before you take the picture.

Make Textures Show Up with Sidelight

Sidelight is light that comes from the side of both you and your subject. It can be high or low, which modifies its effects, but the important thing about sidelight — its ability to highlight textures and dimensions — never changes. Like all other light, sidelight is not arbitrarily good or bad — it all depends on what it is doing to the subject. It can be a harsh light that is very unforgiving to a subject, or it can be the perfect light to show off details.

Make Textures Come Alive

Texture shows up when light hits the high points and shadow fills in between them. That is exactly what sidelight does. It can brighten only the high points because it is not positioned to fill in the low areas. This effect can be quite dramatic with a sidelight that literally skims the surface of your subject.

Use 3/4 Sidelight for Form plus Texture

When a subject has dimension and form, a pure sidelight might not be best for it. In this situation, you might look for a light that comes from the side, but between you and the subject, for what is called a 3/4 sidelight. This type of light makes forms look good and still brings out textures.

Use 90° Sidelight for Strong Texture

When that sidelight is at a 90° angle to the axis between you and your subject, texture can get really dramatic. However, you do need that textured surface to be fairly flat and without a lot of dimensional shape. As soon as the surface gains form, the 90° light literally makes it appear cut in half from the light and dark, and so that texture is not seen well.

Sidelight Can Obscure

Sidelight is a light filled with shadow potential — that is what makes the texture — but it also creates shadows cutting across your subject and background. That can make for a very confusing photo. Hard-edged shadows are the worst in this light.

Separate with Backlight

A lot of photographers are afraid of *backlight* — light that comes from behind the subject and toward the camera. Years ago, amateurs always avoided it because the films, meters, and cameras of the day could not render it attractively. Although this type of light does have its challenges, it is also a dramatic light that professionals use all the time. They also use it to create images that most amateurs never get because the latter do not want to shoot into the light.

Backlight Separates Parts of Your Photo

Backlight is a separation light. This means that the light has a lot of contrast between light and shadow. The light hits the tops of subjects or other parts of your scene, and then contrasts with dark areas just behind them. This helps these picture elements to stand out and become separate from the rest of the image, giving depth to the photo.

Backlight Makes Colors Glow

Backlight really lights up translucent colors and makes them glow against the background. It helps to have the background a contrasting color or brightness for the effect to be strongest. Exposure is always tricky for backlight. Check your LCD playback to be sure your colors look good and not dull.

Backlight Is Dramatic

Backlight is always a light of bright areas and dark areas, highlight and shadow. Because of that, it tends to be a dramatic light. This is another reason that professionals like it. You can use that drama by looking for where the bright and dark areas fall on and around your subject.

Watch Out for Flare

Backlight means that the light is heading right at you and the lens of your camera. That light can both create your photo and bounce around inside your lens, causing annoying flare. Use a lens shade when you can, to block extraneous light. You can also use your hand to shade your lens — just be careful it does not get in your photo!

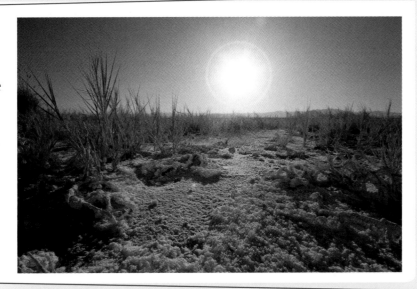

Add Impact with Spotlight

You know what it means to be in the spotlight. It is a theatrical expression that says you are getting more attention. Often you want to do exactly that with your photographs — give your subject more attention. Many lights can act like a spotlight and give that added attention to your subject by putting it in the light, while the rest of the scene is in darkness. Shadows can be as important as the light in order to set off your subject.

A Spotlight Is Like a Theatrical Light

The lights dim and a spot of light appears on an actor. You know immediately where to look and where your attention should be. Light can do the same for your photographs and create a spot of light that tells your viewer exactly where to look in your picture.

Spotlight Can Clearly Show Your Subject

In the theatrical example, you know that the spot-lit actor or action really stands out clearly on the stage. When you can find a spot of light on your subject, that same effect occurs and you ensure that the viewer of your image can clearly see the subject.

Spotlight Can Make a Scene More Interesting

Sometimes a scene that gains a spotlight just picks up interest from the drama that it provides. Many scenes look a little flat in average light. But when the sun changes its angle to the scene, spots of light appear that give life to the scene. Even very average-looking scenes can gain an excitement from this light.

More Exposure Challenges

Spotlights on a scene mean contrast between the bright and dark areas. Anytime you have this contrast, you can have exposure problems. The most common problem to watch for is too much exposure that makes the spot-lit area look too bright, or even washes it out.

Turn On Your Flash When the Light Is Harsh

Nearly all digital cameras have a built-in flash. Many photographers do not know that they can use their flash at all times, including during the day. Keep in mind that your built-in flash is light that is always available and can help you out when the light gets harsh and unattractive. You can easily turn on the flash and just try it, even if it does not always help. Believe it or not, every photo in this section uses flash in some way.

Brighten a Subject on a Dull Day

Sometimes the light just will not cooperate. The day is dull, the sky is lifeless, and the colors just do not look lively. Try your flash to boost those colors. It mainly affects things closer to the camera, but that is often just what is needed to make the scene look good.

Flash Can Make a Dark Subject Bright

A problem in certain kinds of light is that the subject can get very dark. Photographing a subject against a bright background, such as a sky, can make the subject look very dark if the sky looks good. The flash can brighten the subject to a good level, while the camera still keeps the background from getting washed out.

Flash Can Change a Scene

Sometimes a background just does not look great. You can make it dark by using your camera's Manual exposure setting and underexposing the scene. If you are not sure how to do this, just try some settings and see what happens in the LCD. Then turn on the flash and use it normally to give a good light on your subject.

Try a Flash off the Camera

Many digital SLRs have the capability to wirelessly work with a separate flash off camera. All digital SLRs can work with a flash attached with a flash cable designed for the system. This gives you a lot of possibilities to move the flash and change your light's direction, especially when shooting close up to a subject.

Time of Day Changes the Light

Light is not the same throughout the day, yet many photographers insist on photographing the same way throughout the day. That can result in unsatisfying photographs. Early and late light is low in the sky and changes scenes.

Midday light is high and can be harsh and unappealing if photographed the same way as early or late light. By becoming aware of how light changes during the day, you can work with light rather than fighting its effects.

Early Light Is Great Landscape Light

You often hear about nature photographers getting up early for the light. Low, gently colored light of dawn is usually a crisp light that really brings out the features in a landscape. That low light can look great on landscape forms and textures. The good light is usually gone by midmorning.

Use Midday Light for Close-Ups

Midday light can be harsh with ugly shadows because it comes from above. It can be very unattractive for large scenes such as landscapes, and unappealing for people because of the shadows. However, it can work for close-ups because you can easily move around these subjects to find the best light on them.

Late Light Is Warm and Beautiful

As the sun heads down toward the horizon for sunset, it gives a warm light that is usually much gentler than sunrise light. This can be a beautiful light for many subjects, and it also works well from all directions — front, side, and back — although how well it works depends on the subject.

Keep Shooting after the Sun Has Set

For many photographers, it is time to pack up and go home when the sun has set. However, the time after sunset can give excellent results with digital cameras. You may have to wait a few minutes for the light to be its best, but often a wonderful warm, soft light comes from the afterglow of the sunset.

Chapter 4

Understanding Exposure and White Balance

Exposure is a basic part of photography. It is based on how long the light hits the sensor and how much light comes through the lens. A good exposure makes colors and tones look right in the photograph.

Today's cameras have built-in exposure systems that do a fantastic job. But tough situations can challenge that system. Your camera's computer cannot always tell what is important and what is not when the light on the subject is not average. In this chapter, you learn about exposure so that you can make adjustments that will help you consistently get better photos.

What Your Camera Meter Does

A key to understanding how to get good exposure is to understand how your camera meter actually works. Most people think it is designed to give a good exposure. In fact, it cannot do that because a meter can only tell you how much light it thinks is in your scene.

A camera meter does not know what kind of light is there — it cannot know the difference between bright light and a white subject, for example. Its measurements are based on the idea that the scene is average in brightness.

The Meter Only Measures Brightness

Most digital cameras have many tiny meters evaluating a scene. Each one can only measure the brightness of the light coming into the camera from that scene. A meter cannot tell the difference among scenes such as a dark subject in bright light, a bright subject in dim light, and an average scene in average light, and so it can misjudge the amount of light available for a photograph.

Exposure Is Based on Interpretations

The camera's meter alone does not give you an exposure. Your camera takes multiple exposure readings from the scene and uses its computing power to interpret the readings in order to give a good exposure. Cameras use information like focus distance to give emphasis in exposure to the subject, which will be in focus.

Dark Scenes Are Often Too Bright

When a scene is filled with dark colors and tones, the meter has no way of telling that this is not from too little light. As a result, metering systems give too much exposure to compensate for dim light. The result is that the scene is often overexposed, which can result in bright areas losing detail because they are too bright.

Bright Scenes Are Often Too Dark

Conversely, when a scene is filled with light colors and tones, the meter has no way of telling that this is not from too much light. As a result, metering systems compensate for this bright light by giving less exposure. The result is that the scene is often underexposed, which can result in highlights looking muddy and dark areas losing detail.

The Problem of Underexposure

Underexposure causes problems for photographers. You may hear some photographers say that they can fix underexposure in Photoshop, and so they do not worry about it. That is not a good way to approach photography. Underexposure creates some serious quality issues, including increased noise and weaker color. Prints from underexposed image files look muddy and dark. Underexposure uses your camera's sensor poorly because it is not "seeing" the full range of tones that a sensor can capture.

Color Is Lost

Bright colors get dark, but dark colors get very dark. The camera cannot see dark colors the way people do, and the *chroma*, or color intensity, of a color can drop considerably. The result is that even if a dark image is brightened, it ends up with much weaker color. It just looks dull.

Watch Out for Bright Lights

Bright lights, such as the sun or a strong artificial light, usually cause the camera's metering system to underexpose a scene. The meter is just doing its job, telling the system it found something bright, but then the system overcompensates and makes everything too dark.

Dark Tones Become Hard to Separate

When a scene is underexposed, the dark tones get darker. This means that they all cram together at the bottom of the tonal range, into the darkest tones. They can even disappear into black. Once those tones are crushed into the limited area of darkest tones and black, they can be difficult and even impossible to separate again into different tones.

Noise Is Increased

Dark areas are where noise resides. Noise looks like someone sprinkled sand on your photo, adding what looks like film grain. So if an image is underexposed, much of its detail and color ends up in that noise. When the photo is processed to brighten it and make the detail and color more visible, the noise comes right along, and can become quite annoying.

The Problem of Overexposure

Overexposure is usually a problem in small areas. What usually happens with overexposure is that the camera overreacts to something dark throughout the image area, and then makes it too light, which makes bright things way too light. Beware of overexposure whenever small bright areas exist in a large photo with lots of dark areas. Overexposure can also happen when you forget to change the settings of your camera, and that also causes problems.

Highlights Are Lost

When too much light hits your camera's sensor, the brightest areas of a scene overpower its capabilities to capture detail. As a result, detail disappears. There is no fixing it in Photoshop because nothing is there to fix except for blank, white space. Blown-out highlights can be very unattractive.

Colors Get Washed Out

As exposure increases, colors get brighter and brighter. With overexposure, they become so bright that their inherent color starts to fade. Colors wash out, becoming pale renditions of the real-world colors. You can darken pale colors somewhat in the computer, but that takes time and you still miss the original colors.

Shadows Are Too Bright

As exposure increases, shadows brighten, revealing detail within them. That is good if your photo is entirely in the shadows. But if your photo includes a larger scene with bright light, the shadows start to look unnatural and a lot less like shadows. Shadows need to be dark enough that they look like shadows in a photograph.

Overexposure Is Common with Clouds

When bright clouds are an important part of the sky in a big scene, but they are a relatively small part of that scene, the camera tries to expose for the darker ground and sky. This makes the ground look okay, but the clouds lose detail and tonality. They become washed out and a glaring piece of white in the photograph.

Correct Exposure Problems

Now you have an idea of how metering systems work and what exposure is all about. Although your camera works to give you good exposures, sometimes it misses. You can see that the wrong exposure can cause some distinct problems for a photograph, from added, annoying noise to washed-out highlights lacking detail. Your camera does have the tools to correct these problems. Some cameras have more than one, but all cameras have features that help you get consistent, better exposures.

Use Your LCD

Your camera's LCD is a place to start when you check exposure. It is not calibrated the way a computer monitor can be calibrated, but you can still use it. Look at small areas, especially if they are bright. Enlarge the photo so that you can see if the bright areas hold important details or are washed out and empty white.

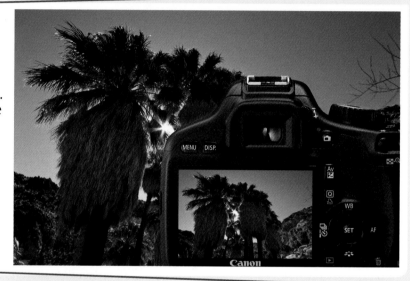

Exposure Compensation Can Help

Nearly all cameras have exposure compensation. This allows you to make the camera give more or less exposure than the metering system chooses. Add exposure and make the image brighter by moving exposure compensation to the plus side, and reduce exposure and make the image darker by moving it to the minus side.

Lock Exposure to Deal with Problems

Most cameras let you lock exposure to limit the metering system's changes. Usually, you just point the camera at a brighter part of the scene to decrease the exposure, or at something darker to increase the exposure, and then press the shutter halfway to lock exposure. You then point the camera back to your subject and the chosen composition.

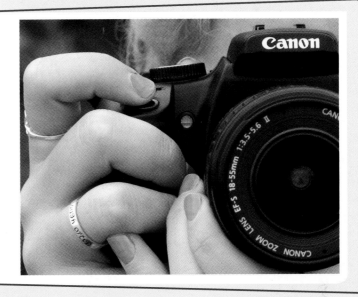

Try AEB

Advanced digital cameras and digital SLRs often include *auto exposure bracketing,* or AEB. This allows you to set the camera to take several photos in a row, each image with a different exposure, so that you can choose the best exposure later. Set the amount of AEB and choose the continuous shooting setting.

What Is White Balance?

White balance is a terrific tool for digital photographers that gives your photos more accurate and pleasing colors by matching the way the camera captures them to the color of the light. White balance affects how an image is recorded so that color casts are kept out of your image. If an object is gray, it will look gray in your photo. If it has a color, the color will look accurate and natural.

White Balance Keeps Neutral Tones Neutral

White balance affects more than white. It makes all neutral colors, from white to gray to black, remain neutral. People's eye–brain connection makes neutrals neutral automatically, but a sensor does not do that. The camera has to be told how light is affecting neutral tones.

You No Longer Need Special Color Filters

With film, you would need specially colored filters matched to a film type to make neutral tones neutral. Without these filters, fluorescent lights made scenes look green, and incandescent lights could give subjects an orange cast. These filters could be used when the photo was shot or when a negative was printed.

Color Casts Are Removed

Color casts used to be a common problem with color film. For example, the whole image would look like it had an orange or green haze to it. Digital cameras let you adjust white balance so that these color casts disappear and a scene looks closer to the way you actually see it.

White Balance Comes from Using a White Card

You might wonder why this control is called white balance. Years ago, a video camera had to be told what neutral was so that it could balance colors to the light. Videographers would point the camera at a white card and set a control that would tell the camera to make the white a true white.

When to Use Auto White Balance

Your camera comes with the ability to automatically make adjustments to get rid of color casts, and to make neutrals such as white, gray, and black truly neutral. This is called *auto white balance,* and is often shown as AWB on your camera. This is the default setting of your camera and works well in many situations, but often it does not work as well as it should. You need to know what it can and cannot do if you want the best from your colors.

AWB Makes White Balance Easy

Auto white balance is simple. You set nothing, and so it makes the control very easy to use. The camera analyzes a scene and tries to figure out what the light is doing to colors. Then it creates a setting for the camera that attempts to make colors look accurate, and to show neutrals without color casts.

AWB Can Cause Problems with Sunrise and Sunset

Your camera's white balance system has no way of knowing that a sunrise or sunset is supposed to have a warm color cast to it. It just sees that all the neutral tones have color in them, and so it removes some of that color and takes some of the life out of the scene.

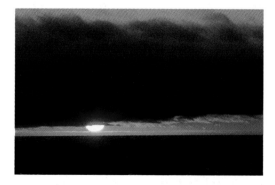 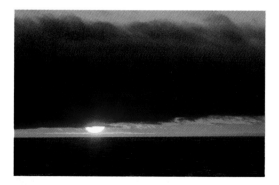

AWB Works in Most Light

A good thing about AWB is that it works in most light. You can go from inside with fluorescent lights to outside sunlight, and expect to get reasonable colors with your camera. AWB is really helpful when you are changing from one location to another or the light is hard to figure out.

AWB Can Be Inconsistent

A problem with AWB is that it can give inconsistent results. For example, when you zoom from wide to telephoto, the camera may see different colors in the background and think that the light has changed. It then adjusts white balance when it should keep it constant.

When to Use Definite White Balance Settings

Your camera comes with a group of preset, defined white balance settings. Even the most inexpensive cameras typically have these controls that take the camera off AWB, but many photographers do not know that they exist. Sometimes you access them from a menu, sometimes directly through a WB button. These settings define the response of the camera to a specific color of light, although they can be used in other conditions for creative effect as well. They can really help you get better color.

Defined Settings Lock the Camera's Response

When you set a specific white balance in your camera, you lock it down to that specific interpretation of the light. This restricts the camera's response to how it interprets a scene, and can ensure that you get more accurate colors.

Defined Settings Are Consistent

With a specific white balance setting, you can zoom your lens in or out and be sure the color of your subject will not change. You can also move around a location and know that a change in the color of the background will not throw off your colors.

Match Settings to Conditions

The basic way to choose a defined or preset white balance setting is to match the setting to the conditions. Choose Sunlight for sunny days, Cloudy for cloudy days, Shade for shade, and Tungsten for indoor light.

Warm Up Your Photos with White Balance Settings

You may like photos a little warmer in tone than the camera gives you. You can change your white balance to always warm up scenes. For example, try Cloudy for a daylight scene or Shade for a cloudy day, and see if the colors look better to you.

Using White Balance Settings Creatively

White balance settings do not always have to exactly match the conditions. You can use white balance settings for creative control that goes beyond simply making colors look more natural. You can choose presets that seem to be completely alien to conditions, just for their effects. There is no rule that you have to use the Daylight setting with daylight — no white balance police will arrest you if you use something different. And there is no quality change to your photo from using something different.

Experiment with White Balance

You start with the Sunlight setting for sunny conditions, but there is no rule that says you cannot use completely different settings for your shot. Just to see what is possible, take a series of pictures of the same scene, but with the white balance set to a different setting for each shot.

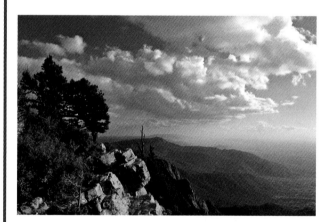

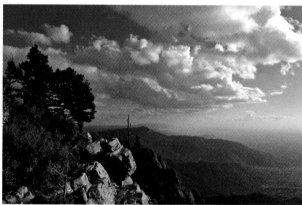

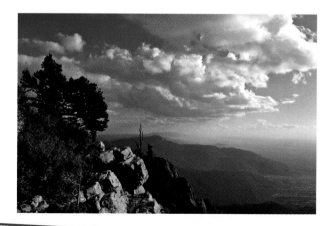

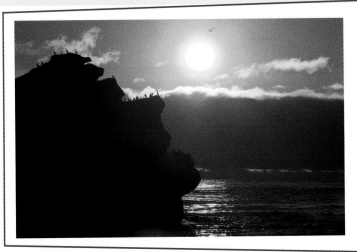

Use the Cloudy Setting for Sunset

Sunset photos are supposed to have rich, warm colors. This is an expectation that comes from how film used to capture sunsets. Digital cameras give much weaker interpretations of sunset unless you choose a specific white balance setting. The Cloudy setting always gives richer sunsets than AWB. Cloudy also helps for sunrise, too.

Try the Daylight Settings at Night

It would seem logical to use a Tungsten or Indoor setting for the lights at night. Yet that often gives such a neutral-looking image that the colors you would usually expect disappear. You can get them back by using a Sunlight setting.

Create Twilight Effects with Tungsten

Tungsten settings are designed for shooting with artificial light, not for daylight. This means that you can get unusual, often striking colors by using Tungsten for daylight. It turns daytime scenes blue, as if they were shot at twilight. With a little underexposure, you can even make them look like night.

Chapter 5

Choosing Shutter Speed and F-Stop

Two basic controls change how much light hits the sensor in your camera: shutter speed and f-stop. Shutter speed affects how long light is allowed into the camera. Shutter speed is often displayed as just the bottom number of a fraction — for example, 1/125 second appears as 125.

F-stop determines how much light is allowed through the lens. Changing the *aperture*, or the size of the opening in the lens, controls the f-stop. A larger opening, such as f/2.8, uses most of the maximum diameter of the inside of the lens. A smaller opening, such as f/11, uses an aperture that is less than the diameter of the inside of the lens.

Control Exposure with Shutter Speed and F-Stop

Shutter speed and f-stop work together to create an exposure for your subject. As a result, you have many options because the combinations of shutter speed and f-stop add up to a very large number of choices. You can potentially use each shutter speed with every f-stop, and vice versa, to match a huge range of brightness conditions. You do not have to choose every setting yourself because the camera will help you with specific choices, depending on the exposure mode you choose.

Shutter Speed and F-Stop Have a Direct Relationship

As shutter speed is changed, a corresponding amount of light controlled by the f-stop must change in order to keep the exposure the same. The camera typically does this for you as you change shutter speed or f-stop with autoexposure. However, with this knowledge in mind, you can affect exposure by using different shutter speeds and f-stops.

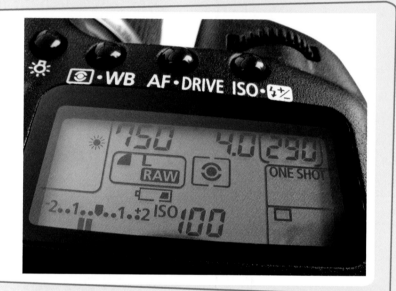

F-Stops Change in a Regular Way

The most common f-stops are f/2, f/2.8, f/4, f/5.6, f/8, f/11, f/16, and f/22. The biggest is f/2, which lets in the greatest amount of light. The smallest is f/22, which lets in the least amount of light. These are full f-stops, and each gives an exposure that allows twice the light through the lens when you go from one f-stop to the next, such as from f/22 to f/16 to f/11, all the way to f/2. Each halves the amount of light when going the other way.

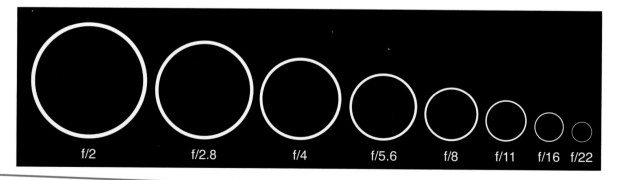

f/2 f/2.8 f/4 f/5.6 f/8 f/11 f/16 f/22

Shutter Speeds Change Intuitively

Shutter speeds represent the amount of time that light hits the sensor, such as 1/125, which may also be displayed as 125. A shutter speed of 1/125 is half the speed of 1/60, which means that it lets in half the light, and twice that of 1/250, meaning it lets in twice the amount of light. Such a change represents a full step or full stop change. The stop refers to a full f-stop change in exposure.

| 1/1000 | 1/500 | 1/250 | 1/125 | 1/60 | 1/30 | 1/15 | 1/8 | 1/4 | 1/2 | 1 sec. |

You Can Choose Either Shutter Speed or F-Stop with Autoexposure

When you choose P or program autoexposure, the camera chooses both shutter speed and f-stop. With A, Av, or aperture priority autoexposure, you select an f-stop and the camera chooses an appropriate shutter speed. With S, Tv, or shutter speed-priority autoexposure, you select the shutter speed and the camera chooses the right aperture.

Stop Action with Fast Shutter Speeds

Fast shutter speeds stop action. If action is an important part of your photography, then shutter speed must be your main consideration. Aperture, or f-stop, is usually far less important. If action is supposed to look sharp — and it usually is — then you need a shutter speed fast enough to stop that action for the photograph. Exactly what shutter speed to use varies depending on the situation. You can choose that speed based on what you discover about the speed of the action. You can try different speeds until the action appears sharp in your LCD.

Movement Is about Time

Anything that moves is changing over time. A slow shutter speed shows how something moves during the time the shutter is open, and so you get a blur. A fast shutter speed captures a moment in time of that movement, a short enough moment to render the action sharp. If your shutter speed is too slow, the action will be blurred even if other parts of the photo are sharp.

Speed of Movement Affects Shutter Speed Choice

Any action has a speed. A person walking has less speed, and therefore less movement through time, than a runner or a bike rider. Shutter speeds must get faster in order to stop action as it increases in speed. You might stop someone walking at 1/125 second, but a sprinter might require 1/500 second.

Angle of Movement Affects Shutter Speed Choice

Your angle to the subject also affects the shutter speed you need. If a moving subject heads toward you, you see less movement over time, and so you can use a slower shutter speed. As the moving subject changes direction and goes at 90 degrees to your view, the subject changes very rapidly going across the scene, and so you must use a faster shutter speed.

Timing of the Shutter Affects Movement

As shutter speeds get faster, such as 1/125 or 1/500 second, time is sliced into shorter and shorter moments. Movement is frozen because the camera captures it in such a short part of its time of action. Every movement contains many such moments, and the timing of your shutter release can change the photograph in dramatic ways.

Blur Action with Slow Shutter Speeds

Shutter speed is not simply about stopping action. A speed can be too slow for a particular action, causing the movement to be blurred. This is obviously a problem if you want to stop the action of an athlete but get only a blurry image. However, blurs can be used creatively and can show a different aspect of the world than we normally see. If you want to experiment with blurs, then be sure to choose a shutter speed that really blurs the subject. Slight blurs look like a poorly photographed subject or a mistake.

The World Is Not Timed to a Shutter Speed

The camera artificially stops action so that you can get a photograph. Movement can be photographed in other ways than simply stopped action, however. When you photograph movement over time, you get a blur, but you also see what movement looks like from a different timeframe.

Slow Shutter Speeds Create Blur

Slower shutter speeds mean that your shutter is open while movement and action occur. That creates blur. There is no absolute for what shutter speed to use. How slow a shutter speed is needed to cause blur depends on the movement. A hummingbird's wings might be blurred at 1/10,000 second, but a snail is not blurred at 1/60 second.

Water Looks Great with Slow Speeds

Water is a classic subject for slow shutter speeds. This allows you to get those beautiful, smooth water shots that actually show the flow patterns of the water. Try shutter speeds of 1/2 to 1 second at first, and then check the results in your LCD. You need a tripod or other camera support for slow speeds.

Blurs Can Be Creative

When slow shutter speeds are used on other subjects, the results can be unpredictable, but also quite attention-getting. For example, try sports action at 1/8 or 1/15 second. Follow subjects as they move, and then release the shutter as you continue to pan with the subject.

Increase Depth of Field with Small F-Stops

Many photographers seek to gain great sharpness throughout their scene. The choice of f-stop has a very big effect on sharpness in depth in a photograph, or depth of field. As you choose small openings or f-stops, depth of field increases. There is a trade-off, however:

As the f-stop gets smaller, less light comes through the lens. This means that shutter speeds get slower, increasing the chance of blur. You often need camera support, such as a tripod, for maximum sharpness when you also want maximum depth of field.

Small F-Stops Have Big Numbers

F-stops are a little confusing because as they get smaller, the numbers get bigger. This is because the numbers actually represent a fraction, so whereas 8 is a larger number than 4, 1/8 is smaller than 1/4. This is exactly what happens with f-stops; f/8 is a smaller opening or aperture than f/4.

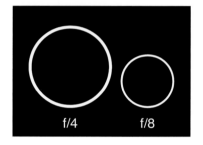

f/4 f/8

Depth of Field Is Sharpness in Depth

Depth of field represents the amount of sharpness in a photograph from near to far, or the sharpness in depth. A photograph that starts sharp with nearby objects and stays sharp into the distance has a lot of depth of field. An image with a very narrow band of focus is said to have shallow depth of field.

Small F-Stops Give More Depth of Field

As f-stops get smaller in size, depth of field increases. A smaller f-stop is represented by a larger number, such as f/16. Use those numbers to your advantage by remembering that larger numbers give more depth of field. Landscapes are good subjects for a lot of depth of field.

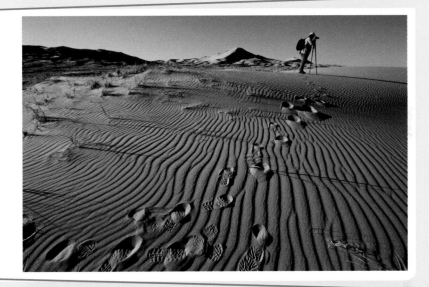

Watch Your Shutter Speed

You can set a small f-stop with aperture-priority autoexposure, or you can watch to see what the camera is doing with other autoexposure modes. You also need to watch your shutter speed. Slow shutter speeds are often needed with small apertures, which can result in blurred photos unless you use a tripod.

Create Shallow Depth of Field with Large F-Stops

Although deep depth of field can be nice for a landscape or a travel scene in some distant city, it can be a problem with some photos. Your subject can blend into a background at times if both are equally sharp. For example, you may not necessarily want the background to be sharp and competing with your nice portrait of your son or daughter. Or, you may want to be sure your photograph of a flower actually makes the flower stand out for a viewer — it will not if the background is too sharp.

Shallow Depth of Field Limits Area of Sharpness

Shallow depth of field limits sharpness in depth. It does not change sharpness from side to side, but it does keep sharpness focused on a specific area of the photograph. This also helps the viewer focus on what is important in your image.

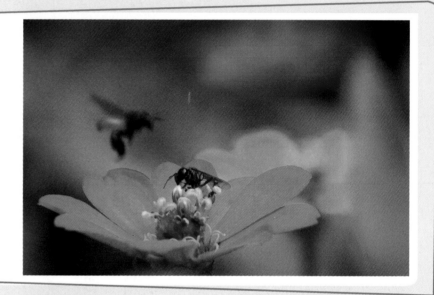

Wide Apertures Reduce Sharpness in Depth

A wide or large aperture in the lens reduces the amount of sharpness in depth possible in a photo. These are the f-stops with the lower numbers, and so you can also remember this by thinking that a low f-stop number creates a low or restricted depth of field. The lower the number, the larger the aperture, and the less the sharpness in depth.

Telephotos Enhance the Effect

Telephoto lenses, or the telephoto portion of your zoom, give less depth of field at any given aperture. Conversely, wide angles give more depth of field. Any time you want to decrease depth of field, use your telephoto lens settings and back up to get the subject into the image area.

Shallow Depth of Field Makes Your Subject Stand Out

So why use shallow depth of field? Because this always makes your subject stand out. The contrast from sharp to fuzzy is always a helpful way of separating your subject from the background. Shallow depth of field is also what you see when focusing through a digital SLR, but is not necessarily what you get when the camera sets the lens to take the photo.

ISO Settings Affect Exposure Choices

Light never remains constant. It changes in so many ways, but especially in brightness. Your camera gives you some control in how the camera responds to that brightness, in the form of ISO settings. These settings change the sensitivity of a camera to light so that the sensor records an image appropriately. Film has ISO numbers that relate to each film's sensitivity. In a similar way, ISO settings reflect how sensitive the camera is to light. The numbers change sensitivity in direct relation to their mathematical change — for example, going from 100 to 200 doubles the sensitivity of the camera.

ISO Settings Boost the Sensitivity of Your Camera

ISO settings on a digital camera are not exactly the same as ISOs of film. Film ISOs reflected a specific sensitivity to light and were locked into a specific film. You can change digital ISO settings at any time. Increasing ISO settings amplifies the sensor's sensitivity to light so that you can shoot more easily in low-light levels.

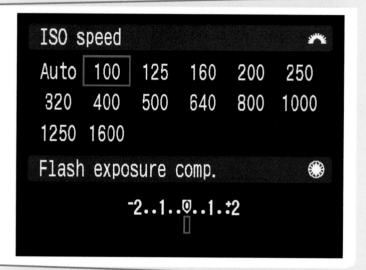

Low Numbers Give Highest Quality

Low ISO settings are based on the native sensitivity of the sensor, and they give optimum color and tonality. In addition, the lowest noise levels come from low ISO settings. The downside is that you often need slower shutter speeds to compensate for the lower sensitivity of the camera, and such shutter speeds can cause a lack of sharpness either from camera or subject movement.

High Numbers Allow Faster Shutter Speeds

Using high ISO settings is like turning up the dial on your radio to bring in a weaker station, although turning up the dial can also increase the static. Higher settings "turn up the dial" on the sensitivity of your sensor and allow you to shoot in lower light levels. The effect of specific high ISO settings varies from camera to camera, but they may result in weaker color and increased noise, just like the static from a weak radio station.

A Caution about Noise

Noise is a pattern of random bits of tiny detail that appear across your image. It looks like sand and is the digital equivalent of film grain. It can be a problem if it distracts the viewer from the subject, but it can also be necessary if you are to get the shot. Noise always increases with high ISO settings and underexposure.

Chapter 6

Getting Maximum Sharpness

For most photographs, sharpness is a key element that helps make the image good or bad, usable or not. A lot of photographers try to "buy" sharpness by purchasing expensive lenses or expensive cameras, yet they are disappointed when their results do not match their expectations.

Sharpness might be considered a part of the photographer's craft. With practice, any craftsperson will get better in that field. If you try the ideas in this chapter, and then practice a bit with them, you will get sharper photos than someone else who does not pay attention to these ideas, regardless of the price of a lens and camera.

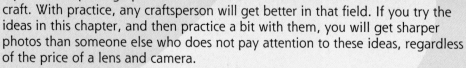

Minimize Camera Movement

Camera movement during the exposure is the most common cause of blurry photos. Small, lightweight digital cameras are easy to casually hold and shoot, yet a casual approach usually leads to less-than-satisfactory photos. For example, those little cameras can move in your hands very easily from a hard push of the shutter button. In fact, all cameras and lenses can have their photos degraded from camera movement or shake during exposure. Holding a camera properly to minimize camera movement is not hard to do, and is a skill worth learning.

A Handheld Camera Moves

Obviously, a handheld camera moves. It has to because you and your hands move. However, many photographers do not consider that possibility when shooting. They take it for granted that somehow the camera will take a sharp photo, and if it does not, it is because the camera is cheap.

How to Hold a Digital Camera

You learned a little about handholding a camera in Chapter 1. Keeping a camera steady while holding the camera is so important that it is worth revisiting here. So often, you see folks holding a little digital camera, with one hand waving in the air. This guarantees less-sharp photos. Hold the camera with two hands and bring your elbows into the sides of your body for the most stable position.

How to Hold a Digital SLR

A digital SLR is held similarly to a regular digital camera, except for the placement of the left hand. Turn that hand palm up, and place the camera down onto the palm. Then grip the lens naturally. This is a much more stable position than if the left hand is palm down.

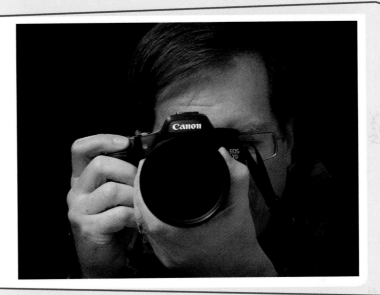

Press the Shutter

How you release the shutter does make a difference. Steadily press the shutter down until it goes off. As noted in Chapter 1, never jab the shutter or quickly lift your finger. Either movement can jar the camera and cause unneeded camera shake during exposure.

Focus on the Most Important Part of the Subject

Autofocus, often called AF, is a great feature on all digital cameras. AF really does help to ensure that your photo is properly focused most of the time. This can be a challenge, however, when you are photographing up close. Then the camera's AF system may focus on the wrong part of the subject because there are so many places to focus on, all at slightly different distances. Whenever you have objects at varied distances within your photograph, you have the possibility of the camera focusing on the wrong object.

Focus Is Narrow When You Are Close

When you get close — and this is not just for close-ups — the area of sharp focus gets narrower. The actual point of focus becomes more obvious. This means that you must become more aware of where the camera is focusing and be sure that the important part of your subject is in focus.

The Camera Does Not Know What Is Important

The camera and its autofocus have no idea of what is or is not important in a photo. Both simply find something that they "know" can be sharp. You have to tell the camera what is supposed to be sharp, and so you need to watch the focus points and notice which ones light up to tell you what is sharp.

The Eyes of a Person Are Critical for Sharpness

In any portrait, formal or informal, the eyes of the person are a key part of that image. They tell a lot about the subject, which is why they must be sharp. If the camera focuses anywhere else, then your photo will be much less effective than it could be.

Check Where the Camera Focuses for Close-ups

With close-ups, there are many spots that a camera can focus on, and they are all very close together in distance. However, what can be sharp is limited because of the distance. You may have to press the shutter to lock focus, as described in Chapter 1, in order to keep focus on the important parts of the photo.

Choose F-Stop or Shutter Speed for Appropriate Sharpness

As Chapter 5 explains, f-stop and shutter speed control exposure. How you choose an f-stop or shutter speed changes the sharpness of your photo, with f-stop affecting depth of field and shutter speed either stopping motion or allowing blurs. This is an important concept to understand when you are choosing either f-stop or shutter speed as your primary control. This section takes a look at both settings from a different perspective than in Chapter 5 — the perspective of sharpness rather than the controls — so that you can better choose what you need.

Foreground and Background Need Depth of Field

A great technique for getting a better landscape photo is to find a foreground that relates to a bigger scene in the background. These images often look their best when both areas appear sharp. You can get deeper sharpness in such images by using the smallest f-stops and a wide-angle focal length.

Fast Action Needs Fast Shutter Speeds

When the action is fast, you must choose a fast shutter speed. Your camera typically has speeds of 1/1000 second and faster. Use them when you can if the action is fast. Let the camera choose a wide aperture if needed, and use a higher ISO setting if you cannot get the speed you want.

Contrast of Sharpness Makes Sharp Areas Look Sharper

When you shoot with a telephoto lens and a wide f-stop, you limit your sharpness to a restricted depth in the photo. This allows you to contrast out-of-focus areas next to the sharp areas. These planes of contrasting sharpness can make your sharp area look even sharper.

Pan Your Camera with Slow Shutter Speeds

With slow shutter speeds, you get blur with a lot of action. Try panning or following the movement with your camera, and then shooting during that movement. This often keeps the subject sharp, or at least less blurred, while the background blurs into an interesting, muted pattern.

Get Maximum Sharpness with a Tripod

A good tripod is probably the best investment you can make for sharpness. You will not use it all the time, but a tripod is invaluable when shooting at slower shutter speeds. Many photographers are surprised at how sharp their lenses really are when they see the results from shooting on a tripod. Even at moderate shutter speeds, such as 1/60 or 1/125 second, most people cannot match the results from a tripod without using faster shutter speeds. The blur from such a handheld shot might not be readily noticeable, but the sharpness of details decreases.

Get a Sturdy Tripod

Too many photographers spend a lot of money on camera gear, and then skimp when it comes to buying a tripod. A light, flimsy tripod can be worse than no tripod. Set up a tripod, lock it down, and lean on it. A sturdy, appropriately stiff tripod does not feel wobbly or like it will collapse.

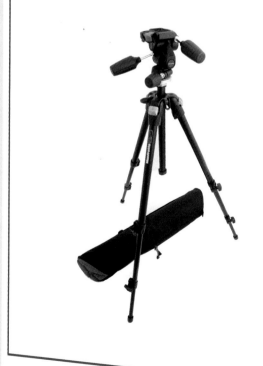

Carbon-Fiber Tripods Are a Good Investment

Without question carbon-fiber tripods are expensive. But their light weight means that you are more likely to take one with you and use it as needed. With reasonable care, they last a long time, and their cost is like an investment in sharpness that will pay off over time.

Ballheads Are Easy to Adjust

The ballhead uses a ball-and-socket mechanism under the camera mount to allow you to adjust the camera angle to the subject. A single knob locks and unlocks the head to move the camera. That single knob makes adjustment quick and easy, but hold the camera firmly as you do, or your camera may drop suddenly to one side or another.

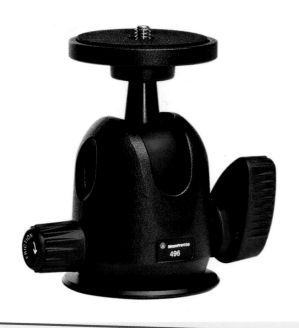

Pan-and-Tilt Heads Offer Tight Control

A pan-and-tilt head is another common top for a tripod. It uses several knobs or levers to adjust the camera position. The multiple controls make it a little slower to use, but some photographers prefer the control it gives over each movement of the camera.

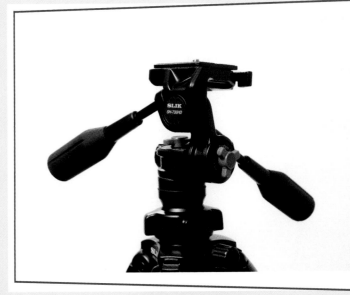

Get Sharpness with Other Camera Supports

Tripods are not the only option for getting added sharpness when shooting at slower shutter speeds. Traveling with a tripod can be difficult if you must pack really light. In addition, tripods can be hard to take to some places, such as when you are photographing along a historic street with a lot of tourists who might trip over them. Some places even prohibit them. Tripods can also be awkward to carry and move around in some settings, such as at sports events. Luckily, you have alternatives.

Beanbags Make Very Portable Supports

Beanbags are very pliable bags that let you prop a camera against a solid surface. Some actually have beans inside, although most have plastic pellets. The bag molds against the camera to help you hold it stable against a post, chair, bookcase, parking meter, or any other convenient, nonmoving object.

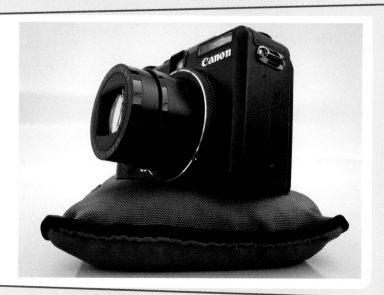

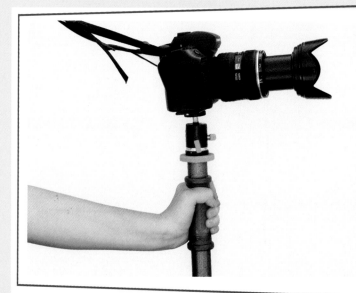

Monopods Are Great for Sports Action

A monopod is like one leg of a tripod with a head on top. These are great for shooting sports because the monopod can carry the weight of the camera and lens as you watch the action develop. They can be used in a lot of situations where you need a slower shutter speed but cannot use a tripod. And you can quickly move out of the way if needed.

Gorillapods Wrap around Objects

The Gorillapod looks like a miniature tripod with bendable legs. It comes in different sizes for different sizes of cameras. Although it can support a smaller camera directly, most of the time a Gorillapod is used by wrapping its legs around a solid object, such as a post. The unit itself is very lightweight.

Tabletop Tripods Can Help with Small Cameras

Miniature, folding tripods can fit into a camera bag, and can be opened and used on a table or any other flat solid surface to keep your camera stable during exposure. The smallest ones can be kept with a pocket digital camera to let you shoot with slow shutter speeds anywhere.

Chapter 7

Getting the Most from a Lens

The lens is a basic part of a camera. The lens controls what the sensor sees — such as how much of the scene appears, what is sharp or not sharp, and perspective. Compact and point-and-shoot digital cameras have built-in zoom lenses that change focal length from wide angle to telephoto. Digital SLRs allow you to choose different focal lengths by changing lenses for specific purposes.

The focal length you use with your zoom and the lens you choose for your digital SLR is a very personal preference. This chapter gives you some ideas on how to best work with a lens to meet your photo needs.

Get a Big View with a Wide Angle

The wide-angle lens is often used specifically to get a wider angle of view on a subject. This is the most common use of such a lens. A wide-angle lens uses any focal length that lets you see a wider view than normal. It is always helpful when you cannot back up from a big view in front of you. Yet a wide-angle lens or zoom setting can do much more for you than simply get more of a scene. It can also be a useful and creative tool that changes how you photograph a subject.

Shoot the Big Scene

The world is a vast place, but it can also often limit you as to where you can photograph. A wide-angle lens can help you get more photographs of those big scenes. Remember that the wide angle gets "wider" top and bottom as well as side to side, so watch what goes into the top and bottom of your photo.

Go Wide Indoors

Digital cameras make indoor photography easy with white balance and ISO controls. A wide focal length lets you see more of the subject and its surroundings when inside. Rooms do not always give the photographer room to shoot easily, and so the wide-angle lens can really help get everything or everyone into the shot.

Make Your Foreground Bolder

One thing a wide-angle lens always does is capture more foreground. Watch out for empty, boring foregrounds that a wide-angle lens can easily capture. Get in close to something special and create a photo with a very strong foreground–background relationship, as described in Chapter 2.

Wide Angle Allows Slower Shutter Speeds

Because a wide-angle lens covers a large area of a scene, it stands to reason that any slight movement of the camera during exposure will be less noticeable. You can often handhold a camera at much slower shutter speeds than expected when shooting indoors if you shoot with the widest angle of your zoom.

Get a Tight View with a Telephoto

Telephoto lenses magnify a scene. Most photographers use a zoom lens for telephoto views, and single-focal-length lenses are available, too. With a telephoto, you can pick out and isolate details in a scene. You can zoom in on things that sometimes cannot even be seen well with the unaided eye. Stronger focal lengths let you bring in subjects, such as wildlife, that sit some distance away so that they fill up your image area. A telephoto lens is an important tool for capturing segments of a wide world.

Telephotos Isolate Subjects

A telephoto focal length allows you to eliminate unneeded details as you zoom in. But it also changes other details, such as perspective and depth of field. This tends to make a subject stand out better against a background, isolating the subject from the overall scene, and helping capture that subject more clearly.

Watch Your Shutter Speed

Telephotos see a narrow bit of the world. Any camera movement during exposure definitely shows up on that restricted angle. You need faster shutter speeds for telephoto focal lengths so that you can stop that movement. Most people cannot handhold any telephoto sharply at less than 1/250 to 1/500 second.

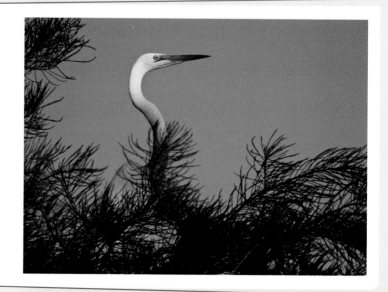

Use Telephoto for Details

As you use focal lengths that increase in telephoto range, you start isolating and focusing on the fine points of a scene or subject. The telephoto lens lets you find interesting details about a subject. Search out color or texture that cannot be seen from a distant or wide view. Use your camera to extract information about your subject that other people miss.

Strong Telephotos Compress Distances

Ever see those photos of cars stacked on a freeway? They are almost always shot with a telephoto focal length. Telephotos bring in the background and make it look closer to your subject. You get the strongest effect by choosing a telephoto focal length, and then backing up until the subject looks right.

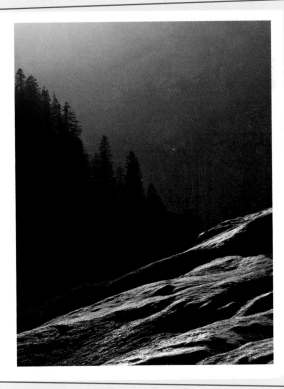

Zoom for Best Compositions

The zoom lens on any digital camera can be a great compositional tool. Composition is always about what you include in your image and what you try to keep out. Your zoom allows you to do exactly that: Zoom out to include more details and more of a scene in the photo, and zoom in to eliminate details that you do not want. You can quickly focus a composition down to its essentials by using your zoom to change what appears in the photo.

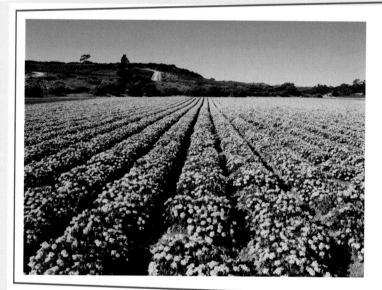

Zoom Out to Include Environment

Sometimes the important thing about your subject is not simply the subject, but how it relates to its environment. Zooming out to a wider setting always allows you to include more of the environment. In addition, depth of field increases, which helps that environment to be more readily seen.

Tighten Your Compositions

One problem many photographers have is that they do not get close enough to their subjects; the photograph has too much space around the really important part of the image. Try setting up your photo how you like it, and then just tap that zoom to magnify it a bit more. That often makes a stronger photo.

Zoom In to Focus on Your Subject

When the focus should really just be on your subject, zoom way in until that is exactly what you see and nothing else. You can make a subject look very dramatic if you get in close and use your zoom to its maximum magnification. If the subject is too pressed in by the edges of the composition, back up — do not simply zoom out wider.

Experiment with Your Zoom Range

If you want to learn the capabilities of your zoom better, here is a good exercise. Take a series of 30 photos, where each image uses a different extreme of focal length. Take the first photo at full wide angle, the next at full telephoto, the following shot at full wide again, and so on. This can be a challenging and fun exercise.

Choose Focal Lengths for Different Subjects

As you think about focal length, you will quickly discover that certain focal lengths seem to fit specific subjects quite well, such as landscapes with wide angles and wildlife with telephotos. It is worth keeping that in mind. Although you can certainly photograph any subject with any focal length, you will find that some subjects are just easier to photograph with either telephoto or wide-angle lenses, but not both. It can be frustrating to try to force a subject into an image that the lens does not support.

Telephotos Are Great for People

Telephoto focal lengths can be very flattering for people. Try setting your zoom to a moderate telephoto position, and then back up until your subject looks good. With most standard zooms, this provides a very pleasing perspective for a person's face. It can also blur the background so that the subject stands out better.

Capture Wide Landscapes

Landscapes are often big, and you frequently have a limited location from which to photograph them. If you like photographing big spaces, a very wide-angle lens may be a necessity for you. You can get such lenses in some compact digital cameras as well as digital SLRs.

Strong Telephotos Help with Wildlife

Wildlife does not generally sit still while you come up to photograph it. Even relatively tame animals are not comfortable with close approaches. You need a strong telephoto in order to photograph them. Common zoom ranges on pocket digital cameras are typically too small to work for this subject.

Wide Angles for Travel

When you are traveling, you often need to show off a scene, and yet you are limited in where you can photograph from. A wide-angle lens can be great to get a quick shot of a nice location without spending a frustrating amount of time finding a place to stand. Wide-angle lenses also let you show the whole environment of a scene.

Close-ups and Lenses

Close-up photography is a fun way to use your camera. All cameras today have the capability of focusing close, although some do better than others. Specialized lenses optimized for close work can be helpful, but you do not need them for starting to shoot close-ups. Set your camera on its closest focusing distance (or set to close-up focusing) and move in to find interesting subjects for your photos. If you want to go closer, your needs may be as simple as a special close-up lens.

Try the Close Focusing Setting

Even the most basic point-and-shoot camera usually has a close-up setting that allows very close focusing within inches of your subject. This setting is represented on most cameras with a flower icon. Give it a try with some subjects in your area. Most zooms for digital SLRs also have close-focusing settings that you can use to create close-up work with those lenses.

Add a Close-up Lens

An easy way to get closer shots with many lenses is to use a close-up accessory lens that screws into the front of your lens. You can even use these lenses with many compact digital cameras as well as digital SLRs. Look for achromatic close-up lenses for the best sharpness.

Extension Tubes Work with Digital SLRs

An extension tube is literally that — a tube that extends the distance from camera to lens. It allows all of your lenses to focus closer, although wide angles might not work. Extension tubes are very affordable accessories that open up close-up and macro photography for any digital SLR.

A Macro Lens Has Unique Features

You do not need a macro lens for close-up or macro work. However, such lenses do have advantages. They allow you to focus from a distance to up close without any other accessories or camera settings. They are also designed for maximum sharpness and detail when you are shooting very, very close to a subject.

Focal Length and People Photographs

Earlier, this chapter explained that telephoto focal lengths work well with people. This is true, and you are always safe photographing people with such focal lengths. However, good people photographers use all sorts of focal lengths to control the portrait even more. You can get very unflattering photos if you use a focal length inappropriately, but all focal lengths work for people photos if you use the right approach. Do not simply use a lens to get wide or narrow; check the LCD and look at what the lens is really doing to your subject.

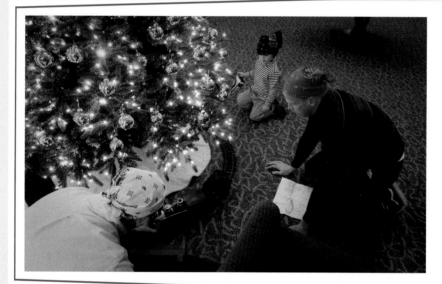

Wide Angles Show a Person's Setting

As described earlier in this chapter, wide-angle lenses let you add some environment around your subject. This can be a great way to tell a story about your subject by showing it in a personal space. Such images can bring texture and color to a portrait by keeping the subject in context with its surroundings.

Telephotos Let You Isolate People

When you zoom in and concentrate on just the person's face or face and upper body, you make your viewer really look at that person. Such a close view focuses in on the face and eyes, a critical part of a portrait. It then isolates the subject by keeping distractions out of the frame. The telephoto also lets you do this while keeping a comfortable distance from your subject.

Wide Angles Up Close Give Striking Results

Many photographers shy away from shooting people with wide-angle lenses, especially up close. It is true that such a technique can give some wildly distorted looks to a face, which not all subjects appreciate. Yet you can also create striking images that grab you in a way that no other technique can do.

Be Careful of Focus with Telephotos

Remember that telephoto lenses have a limited area of focus. You need to be careful that your camera's autofocus is not focusing on the wrong parts of a face — for example, the tip of the nose or the ears. Work to be sure that focus is on the eyes. Sharp eyes are critical to photos of people.

How to Buy New Lenses

Lenses can be a seductive attraction for a digital SLR owner. There are many lenses on the market, and they all offer excellent results. That can make buying a new lens rather confusing. Each lens has its pros and cons related to specific photographers or subject matter, yet the lens can be so attractive that photographers end up buying gear not really suited to them. Here are some ideas for what to consider when you want to add a lens to your bag.

Look at Your Limitations in Picture Taking

The first thing to consider is what you feel is limiting you as a photographer. Do you wish you could get closer to wildlife? Then look at long telephoto lenses. Do you find you cannot get back far enough to capture landscapes you like? Then look into wide angles. Base your choices on what is challenging your photography.

Be Wary of Other Photographers' Advice

It is quite easy to get impressed by another photographer's gear. He will tell you how great or bad a lens might be. Understand that lens choice and use is very personal, and what works for one photographer might be wrong for another. Look at how a lens really might fit your needs, not just how it works for another photographer.

Expensive Is Not Always Better

Expensive lenses are better than lower-cost lenses, right? Not necessarily. A lot of factors go into deciding on a lens. A lens with a large maximum aperture such as f/2.8 for a telephoto is very expensive, yet it might not be any better than the same focal-length lens with a maximum aperture of f/4 that is much less costly. Large maximum apertures can be very expensive to produce.

Big-Range Lenses Are Great but Not for Everyone

If you want to travel with one lens, you might want to get one of the big-range zooms, such as 18-200mm. That gives you a lot of telephoto and wide-angle focal lengths in one lens. However, such lenses are also generally quite slow, meaning that the maximum f-stop, especially at the telephoto end, is small and lets in less light. This can be a serious limitation in low light.

Chapter 8

Indoor and Night Light plus Flash

Conditions indoors change, from the time of day to the type of room to the kind of lights. With film, those varied conditions made indoor photography challenging. Night photography could be even worse. You never knew exactly what the light would do to contrast and color.

The digital camera has been a huge boon for dealing with the artificial light of indoors and night because you can actually see results as you take the pictures. This opens up so many possibilities. You can now shoot literally almost anywhere there is light and get good photos, yet most photographers still do not shoot at night because they remember the bad results of film. Night photography can really help you capture unique and striking photos.

Deal with Artificial Light

Artificial light is the light you find indoors at home or at the office, in an arena, in a high-school gym, at night on the street, in a manufacturing plant, and in a restaurant — basically, light other than sunlight. This light can be very interesting, but it often presents challenges for the photographer, including sharpness, noise, contrast, light quality, and light color. Successful artificial light photography requires that you learn to deal with those conditions.

Deal with the Sharpness Issue

When you go inside, or if it is night, light levels usually drop, which often requires slower shutter speeds for exposure. If you are not careful, such a change in shutter speed can make images less than sharp from camera movement that occurs from handholding a camera, or it can mean that subjects are blurred from their movement.

Light Color Can Be Interesting

The color of light can vary all over the place indoors and at night. This can be a problem when odd colors appear that are unattractive with your subject. On the other hand, the variation in light can be quite interesting and create images that cannot be captured in any other way.

What to Do with Contrast

Your eyes can see more detail in a contrasty scene such as night scenes than the camera can, but this goes beyond the night. You need to begin seeing like your camera and avoid angles and compositions that favor a subject as you see it but that look bad as a photograph because of too contrasty a light. Use your LCD to see what is really happening to your subject in that light.

Why Noise Is Such a Problem

Low light usually means higher ISO settings, longer exposures, and often, a risk of underexposure. All of these can increase noise to unacceptable amounts. However, sometimes the only way to get the shot is to use a high ISO setting, and so you need to be especially careful of underexposure that could add even more noise.

Correct Color with White Balance

Color differences in light are often magnified when you get out of the sun. Just try photographing a blond-haired person in a room with both fluorescent and incandescent lights; their hair shows off multiple colors from those lights. Artificial lights have so many different colors, and their light affects subjects in both good and bad ways. You can continue to control this with white balance, as explained in Chapter 4, but the choices are not always clear cut indoors or at night.

Make Your Subject Look Good

If you are photographing a subject where color is critical, such as a person's skin tone, choose a specific white balance to match the light on that subject. Someone viewing your photo will tolerate all sorts of odd colors if a key color looks good. Skin tone is one of those colors that really looks bad if it is off.

Create a Mood

Color affects mood. You will find that certain scenes look better with a color cast that influences the mood rather than a purely accurate color match. For example, lights at night often look better when they look a little warm, instead of white-balancing the scene to make them neutral.

Emphasize Colors in Light

When you have a scene with varied colors of light, each light appears differently when you change white balance settings. This is a good case for not using AWB, or auto white balance. AWB often gives you less effective colors because it tries too hard to compromise. Take some test shots and compare with different white balance settings.

Try Custom White Balance

Sometimes the colors indoors or at night just do not look right, no matter what white balance setting you try. This may be the perfect time to use your camera's custom white balance setting. Use a white or gray card in the same light as the light that hits your subject, and white-balance on it.

Unfortunately, camera manufacturers have not standardized this process, and the camera can actually do this in many ways. Check your manual and you will usually find it is pretty simple to do. For example, the manual may suggest taking a picture of the white or gray card, and then telling the camera to remove the color in it.

Using Appropriate Shutter Speed Technique

Low light indoors or at night really taxes your camera's ability to use reasonable shutter speeds for sharpness. Even high ISO settings and wide-open lens apertures still result in slow shutter speeds. This is why night photos often do not look as sharp. The camera has too much potential to move during a slow shutter speed. Flash eliminates that blur, but it also removes the feeling and mood of the scene's light. You can do the following things, however, to get sharper photos.

Watch Your Handholding Technique

How you hold your camera makes an especially big difference when the light is low. Be sure you have stable hand positions, with your elbows in, two hands gripping the camera, and the left hand supporting the lens of a digital SLR from below. Then press the shutter with a steady release — no jabs.

Use Wide-Angle Focal Lengths

Because wide-angle focal lengths can be handheld at slower shutter speeds than telephotos, they can be a real help when the light levels drop. Set your zoom to its widest as you shoot with slow shutter speeds. Never use telephoto focal lengths handheld in these conditions unless you have a lens with a wide maximum aperture and conditions are brighter.

Try Continuous Shooting

Set your camera to continuous shooting when the shutter speed gets slow. Then take a series of photos by just holding down the shutter. Very often, one of those shots will be sharp when the others are not. You are not moving much when such shots are made, and you cannot push the shutter release too hard.

Breathe Right

Many people think they should hold their breath when photographing with slow shutter speeds. That is a fallacy. Holding your breath can make you shake. Instead, use an old rifle shooter's technique: Take a big breath, and then let it out slowly, releasing the shutter as you do.

Brace the Camera for Sharpness

As day changes to night and you begin to photograph under changing light, there will be some point, depending on the focal length of your lens, where shutter speeds will be too slow to hold steady without support. Telephoto focal lengths need a faster shutter speed than a wide-angle lens when you are shooting handheld. A tripod can help and can be an important tool for shooting at night, but sometimes you just cannot use one. In these situations, you have other options.

Brace the Camera against Something Solid

You can almost always find something solid to brace your camera against when you are inside. Think about the possibilities: door frames, chair backs, shelves, lamp stands, tables, and more. You can often shoot at quite slow shutter speeds when you have a camera pressed solidly against a bookshelf.

Try a Beanbag with a Screw

Beanbags are wonderful stabilizers for a camera. However, they slide easily from under the camera when the support area is not flat. Manfrotto Distributing, formerly Bogen Imaging, markets a beanbag called The Pod that includes a tripod screw in the middle. This lets you attach the beanbag so that it stays right with the bottom of the camera, no matter where it is.

Look for Anything to Steady Your Camera

When you set a camera on a solid surface, the lens is often not aimed right. Look for anything that could be used to stabilize the camera at the proper shooting angle. For example, that could be a sock, rolled-up paper, a shoe, or added fingers. Be imaginative, as long as the camera does not wobble.

Tripods Give Great Results

When you want the sharpest results in low light, you have to come back to the tripod. A tripod keeps the camera from moving during typically long exposures. If your camera has a two-second self-timer, use it when shooting long exposures on a tripod because it helps the camera and tripod settle from any vibrations.

Understand How Flash Works

As interesting as indoor and evening light can be, after a while, you have to use a flash. A flash is a controlled light in color, direction, and intensity. It happens too fast for you to see anything other than a flash. The camera uses that flash to calculate a correct exposure for your subject and scene. In addition, you can always check your flash photos in the camera LCD to be sure exposure is right and to see if you have problems from the light of your flash.

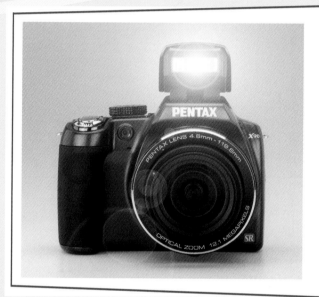

The Camera Controls Flash Exposure

Cameras today have a lot of computing power built into them. A digital camera meters the results of a flash over multiple spots across the image area, compares those readings, and then calculates an exposure for the scene. The meter works like it does with normal exposures and can be overly influenced by light or dark subjects.

Digital Photography Needs a Pre-Flash

You may have noticed a double flash when you use flash with your camera. The camera sends out a first burst of light from the flash to see how much light is needed to create the exposure. It measures the light coming back from that flash and calculates the second, real exposure from that.

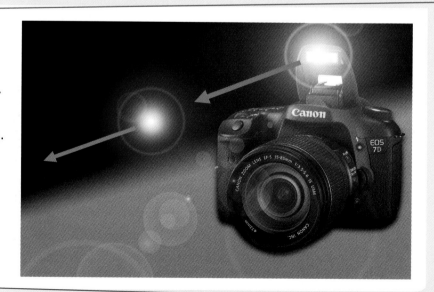

Accessory Flash Offers Options

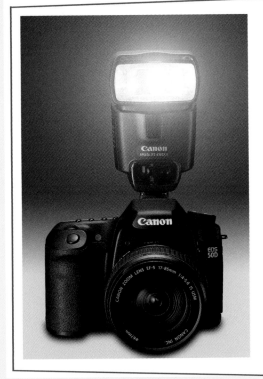

An accessory flash is a separate unit that usually attaches to a flash shoe on top of the camera. All digital SLRs can use them, as well as some compact digital cameras. These units have a lot more power and versatility than a built-in unit. You can also get many kinds of accessories for them that help control your light even more.

In-Camera Flash Is Helpful but Limited

In-camera flash is very helpful because it means that you always have a flash with you. You can turn it on whenever you need more control to your light. However, it is small and does not have a lot of power. It may have little effect on subjects farther than about 10 to 15 feet away from the camera, and you cannot modify much about it, such as adding a diffuser.

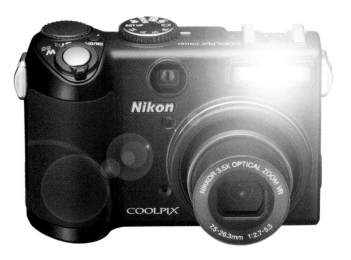

Deal with Red Eye

Anyone who starts photographing people at night with a flash will run into red eye. Subjects look possessed because their eyes glow red. This also happens with animals, but their eyes have different colors, such as gold or green. Regardless, this is rarely a desired effect. Red eye is distinctly unflattering for people, making it terrible for party photos — where red eye is so commonly found. Red eye settings for a flash can help, but there are other solutions, as well.

Red Eye Is a Flash Effect

Red eye comes from the flash and the flash alone. What happens is that in dark conditions, the pupils of eyes get larger. This allows more light to get inside the eye. If the flash is close to the axis of the lens, it reflects off the back of the eye at the camera. The flash is so much brighter than the scene that this effect shows up in the form of red eyes.

Flash Away from the Lens Reduces It

Red eye occurs when the flash can reflect directly from the back of the eye to the camera lens. When the flash is away from that axis, its light cannot reflect directly back to the camera. The farther a flash is up from or to the side of the lens, the less likely you are to get red eye.

Red Eye Reduction Methods Sometimes Work

Digital cameras have a number of ways of trying to reduce red eye. Cameras sometimes turn on a bright light, including quick bursts of the flash, to try to force pupils to contract. This can be distracting to a subject. Some cameras include built-in red eye processing of the image file that can work quite well.

Bright Light Limits Red Eye

Bright light makes people's pupils contract so the flash cannot easily reflect off the back of the eye. Although cameras sometimes offer this, it can be distracting. It is often better to ask your subjects to move to a brighter spot or to have them look momentarily at a nearby bright light before you take their picture.

Avoid Flash Shadow Problems

Flash is a very direct light. Because it comes from a small, but very bright, source, it is called a *specular* light source. Specular light creates hard-edged, very noticeable shadows. Such shadows are neither good nor bad, but when uncontrolled, they can cause problems in your flash photographs. Shadows can be interesting or distracting, complementary or conflicting. You have to decide what you want to happen when you use flash for a scene.

Flash Creates Harsh Light

The first thing most people notice with flash is that the light can be harsh. This comes from both the contrast from bright to dark and the hard edge you will find along the boundary between shadow and light. You can use this for creative effect, but be aware that it can make subjects look too harsh.

Try the Night Flash Setting

Many digital cameras have a night flash setting that forces the camera to use a slower shutter speed. This balances the light from the flash with the existing light so that there is less contrast between the subject and the background. The background gets lighter and the image looks less harsh. But remember that you are shooting at a slow shutter speed, so be sure to hold the camera steady.

Off-Camera Flash Is a Possibility

If your camera can take an accessory flash, it can also use a dedicated flash cord. This cord lets you take the flash off the camera for better-looking shadows and a more dimensional light on the subject. Some cameras even have wireless capabilities so that you trigger a flash off camera without a cord.

Soften Your Flash for Good Effect

A softer flash is flash that has its light spread out. A white sock can do the job, or you can purchase inexpensive, easy-to-use diffusers that attach to a flash to spread out its light. These reduce the light a little, but the camera automatically compensates for that. As the light spreads out, the shadows and their edges get less harsh. The effect is strongest when you are close to the subject.

Bounce Your Flash for More Natural Light

As you have seen, light coming directly from a flash can be harsh and unattractive. Yet this need not always be the case. Look at any fashion advertising; almost 100 percent of it is done with flash, but the flash is often bounced off a big, reflective surface. That bounce makes the light appear bigger, meaning that it spreads out considerably. This spread is what makes subjects look better, with much more appealing light. The larger the light, the more sharp shadows tend to disappear.

Tilt Your Flash to the Ceiling

The quick and easy way to start using bounce flash is to get a flash that can tilt the actual flash tube part of the unit upward. Most accessory flashes allow you to do this. This immediately creates a large, gentle light source from above that is very natural looking. Be sure the ceiling is white, reflective, and not too high, or this will not work.

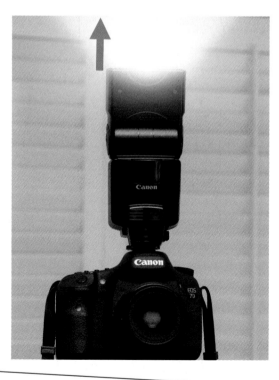

Turn Your Flash to a Wall

Many accessory flash units turn left and right. This allows you to bounce the flash off a wall. Look for a white or light wall. If the wall has any color, it will show up in the photo. Warm white is okay. Bouncing light from the side gives you a very pleasant light with directional qualities to it.

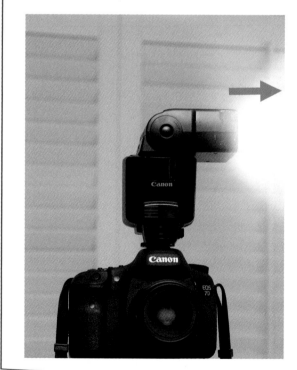

Bounce Flash Makes the Light Gentler

Bounce flash works because the spread-out light on the wall or ceiling is large. This means that light can hit your subject from more angles, giving a gentle edge to shadows, yet still giving a very pleasing dimensional light. The bigger the bounce area, the gentler the light appears.

Off-Camera Bounce Changes Shadow Direction

With a flash-dedicated extension cord, you can get the flash off the camera and pointed wherever you need the light. You can then quickly go from a direct but very directional light to instantly pointing the flash at the ceiling or a wall. That totally changes the light and gives better shadows.

Shooting Video with a Digital Camera

High-definition video is now an important feature in most digital cameras. Video is a very new feature for digital SLRs, and its incorporation into these cameras has changed photographers' impressions of what a camera can and cannot do.

Video is different enough from still photography that it intimidates a lot of photographers. Video does not

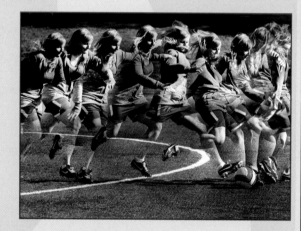

have to be a problem — it can be a great opportunity for you to try something different with your camera. Video gives you the chance to capture motion and sound with your images, and for some subjects, that can allow you to show off things about those subjects that were never possible before.

Choose the Right Shutter Speed

Video restricts the shutter speeds you can use. With still photography, most cameras allow you to shoot with shutter speeds as fast as 1/2000 second to as long as 30 seconds, and with many cameras, you can choose both faster and slower speeds.

Those options do not work for video. For most subjects, you will be shooting in a range of 1/30–1/90 second. This is an optimum range that both works with the technology of video and gives good-looking video. This also restricts the f-stops you can use because exposure is dependent on a relationship between shutter speed and f-stop.

Choose a Shutter Speed Faster than 1/30

Video is made up of approximately 30 still frames per second. Your camera must capture those 30 shots continuously during each second of video. That means it is impossible to use a shutter speed of less than 1/30 second and still be able to have video. For example, you could get only 20 shots per second with a shutter speed of 1/20 second.

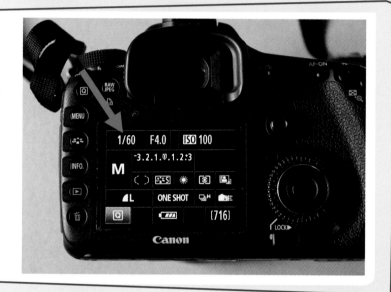

Fast Shutter Speeds Make Video Look Bad

If a camera is shooting 1/30 second for the 30 frames of video per second, that second is pretty much filled with visuals. If you shot at 1/1000 of a second, you would be recording only 30/1000 of that second, leaving 970/1000 blank. That is a problem because it makes any action in the video look choppy and not smooth.

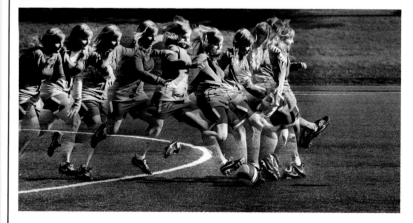

Still Images from Video Often Look Bad

Some people think that because high-definition video has a higher resolution than standard video that it can be used for still photos, too. You simply take the still photos from the video. This does not work for action because the slow shutter speeds needed for video result in blurry photos. The slow shutter speeds make the video look great, but not still images from it.

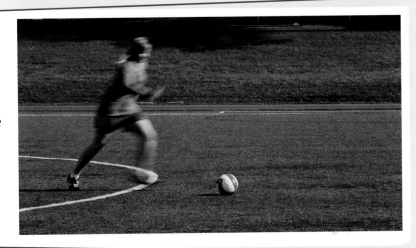

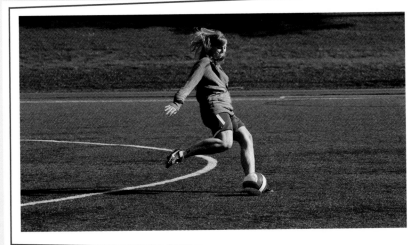

Choose a Fast Speed for Special Needs

One thing that high shutter speeds do with video is stop action. If you want to record an action, look at the individual steps of that action, and then you can shoot with a high shutter speed. The video looks jerky and choppy, but you can freeze-frame the action and actually see details of something like a golf swing.

Using ISO Settings to Change Exposure

Because shutter speed options are limited with video, you need to use your ISO settings more often than you would for shooting still photos. ISO settings change the sensitivity of the camera so that it handles certain brightnesses of light better. Bright conditions need less sensitivity from the camera. Dim conditions need more sensitivity from the camera.

It is best to choose a specific ISO setting and not use auto ISO. You should select a camera sensitivity based on the specific needs of the subject and the conditions in which you are shooting. That means selecting a specific ISO for the conditions.

Use Low ISO Settings in Bright Light

During daylight conditions, the light is generally bright. You can usually choose a low ISO setting for these conditions, such as ISO 100 or 200. Too high an ISO setting causes you problems with exposure. A low ISO setting gives you optimum image quality whenever you can use it.

Choose High ISO Settings in Dim Light

When light levels drop as the day turns into night or you move inside, you need to start changing your ISO to higher settings, such as ISO 400 or 800. These allow you to continue to shoot even though the light gets dim. You may have to shoot with your lens at its maximum aperture, which is the smallest number f-stop.

Watch for Noise from Very High ISO Settings

Very high ISO settings such as ISO 1200 and above can be tempting. They can make it much easier to shoot under very low light levels. But understand that when you choose these very high ISO settings, you may be increasing the noise in your video by quite a lot. That may or may not be an acceptable trade-off for being able to get certain types of shots.

Change Your ISO as Conditions Change

When you move from indoors to outdoors or vice versa, remember to check your ISO setting. It can be very frustrating if you go outside with too high an ISO setting that will not allow you to shoot. It can also be very frustrating if you go inside and try shooting at too low an ISO setting. Start doing this and checking your ISO will become a habit.

Support the Camera

With still photography, you simply point your camera at the subject and take the picture. You are done. Video does not work that way. When shooting video, you are always shooting over time, without the instantaneous moments of photography. Video records something as it happens. Because of that, there are some limitations as to how you handle your camera. If you take a still photo and move the camera one second after you have made the shot, there is no problem. If you start shooting video and move the camera one second later, that can be a big problem for your viewer.

Video Is Shot over Time

Because video is about shooting something over a period of time from seconds to minutes and more, you need to have some way of supporting your camera. It can be very difficult to hold the camera still over the time of shooting without that support. Sure, tripods can be inconvenient, but they are a sure way of steadying the shot for your viewer.

00:10:24

Use a Fluid Head

A standard tripod head is designed to hold your camera still. If you want to move your camera by panning across a scene or tilting up and down a subject while recording it on video, that standard tripod head can give very jerky results. For smooth movement of the camera, you need a video or fluid head. These heads are designed to create a smooth pan or tilt.

Do Not Make Your Viewers Seasick

When photographers start shooting video, they have a tendency to constantly move the camera around the scene. Remember that your viewer is then locked into seeing only movement — they have no reference of something solid that can keep them from getting dizzy. Such movement can truly make viewers seasick.

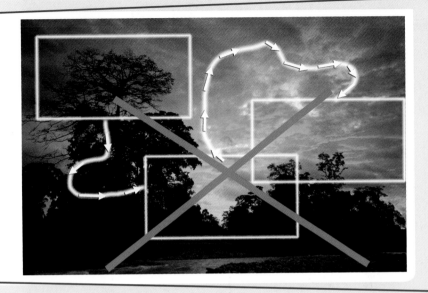

Try a Monopod

A monopod is a very good support for video because it helps keep your camera steady while shooting, yet it is easy to carry and relatively inexpensive. You need some sort of tripod head on top to tilt your camera up and down, but you do not need anything for side-to-side movement because you can simply swivel the monopod on its leg.

Capture a Variety of Shots

Shooting over time does not mean setting down your camera and just turning it on for many minutes. Such video would be boring to most people and probably unwatchable. People are so used to watching movies and television that they expect to see a variety of shots as the video unfolds. Watch everything from television news to documentaries to kids' shows and more and you will see that a variety of shots are always used in recording these shows. Viewers expect to see some change in the shots, and without that variation, editing your video can be very difficult.

Use Wide Shots for Environment

A wide shot is simply a shot that shows a large part of the scene. This does not mean you have to use a wide-angle lens; simply frame your subject matter so that you see a big area. This large scene helps your viewer understand the environment and setting of your subject. It gives a feeling of place.

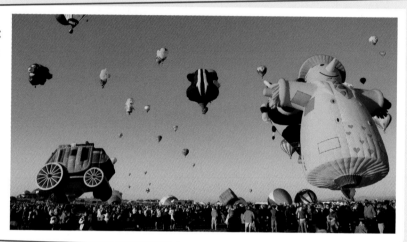

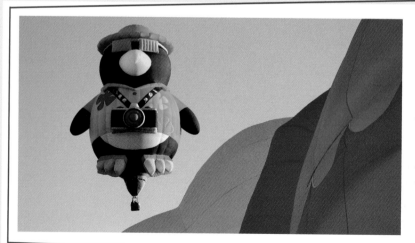

Try Medium Shots for Relationships

Get in closer to your subject by either moving closer or using a zoom lens and you will tighten your shot to just the subject and its immediate surroundings. This creates a visual relationship between the subject and whatever is nearby in the shot. This can be anything that helps the viewer know more about the subject.

Go for a Close Shot for Details

Close shots are shots that bring the viewer in very close to the subject or parts of the scene. These shots come in so close that you can see details. These details are then highlighted and emphasized by video. Such shots contrast nicely with medium and wide shots. Such contrasts can help you tell a story about your subject.

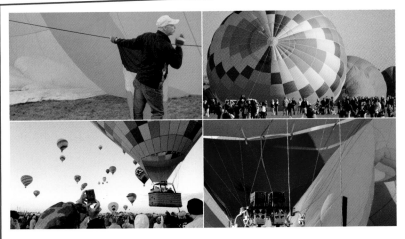

Capture Enough Video

Video is dependent on having enough variety of shots that you can edit them together into an interesting program or show. If you shoot only a couple of pieces of video, you will have little to work with when editing them together. Shoot more, and you have more to work with. This is one reason why you need large memory cards for shooting video.

Look for Movement

Video works best with some sort of movement. That does not mean that you need dramatic movement in every shot — that can be very hard on your viewers. Sometimes movement comes from the way different shots are put together.

However, whenever you can find movement in a scene, use it. This makes your video more interesting and allows you to have longer shots on-screen. Viewers like to view static, unmoving subjects only in short shots. With every movement by or around the subject, the viewer keeps watching as long as the shot is interesting.

Keep Shooting as Your Subject Changes

Even seemingly unmoving subjects, such as a landscape, often reveal movement. The wind blows, trees flex, dust rises, and so on. Watch for such movement and frame your shot to include it. Then keep shooting until the movement occurs. Small but obvious movements can enliven any scene.

Pan the Camera Carefully for Wide Scenes

A wide-angle lens often includes a lot of extraneous detail at the bottom and top of the frame. You can zoom into an important part of the scene, and then *pan* or move your camera across the screen from left to right or right to left. Practice this movement a couple of times before actually recording it. Watch for speed and smoothness.

Move Your Camera with the Subject

When a subject is moving, you can pan your camera with the subject or even handhold the camera as you follow the subject. This creates an interesting emphasis on your subject. Handholding your camera with a telephoto focal length can be difficult unless you have a lens with image stabilization or vibration reduction built in.

Move Your Camera through the Scene

Hollywood movies often have the camera moving through an interesting scene. This gives a very different feeling than simply zooming your camera in or out from a fixed position. This is best done with a wide-angle focal length because that minimizes bouncing movements of the camera.

Record Good Audio

Video is about both the visuals and the sounds or audio of what you are recording. Good audio can make the visual look better, and bad audio can make it look bad. Photographers often find it challenging to think about sound as well as what the lens of the camera sees. Yet if you want good video, you have to start listening to as well as seeing your subject and its environment. You do not need a lot of fancy new gear to capture good audio, though an external microphone helps. The biggest thing you need is an awareness of the sounds around you.

Get the Microphone Close to the Subject

Your camera records the visual part of video based only on what it sees through the lens. The microphone picks up every sound around you. To help your microphone better capture the important sounds, get it as close as possible to your subject. This is especially important when you are recording from the microphone built into your camera.

Use an External Microphone

The microphone built into your camera has some severe limitations. It picks up a lot of sounds from the camera and your handling of the camera, plus it is not that high quality. A simple shotgun microphone mounted to the hot shoe of your camera is a low-priced option. It helps focus the recording of your sound to what is important.

Listen for Sounds around You

Your camera only sees what is in front of the lens, but sound is recorded from all around you. It is easy to focus your mind on what you are seeing through the camera and not hear sounds going on all around you. Yet the microphone hears those sounds, so it pays to pause and listen to what is going on around you.

Avoid Clothing Sounds

You probably never paid attention to it, but a lot of clothing makes noise as you move. Because the camera is near your clothing, the microphone quickly picks up such noises. Wear soft clothing, or if your clothing is noisy, restrict your movement when the camera is recording. The same advice applies to the subject.

Chapter 10

Editing and Organizing Your Photos

Taking pictures is easy and fun. But now that you have all of these photos, what do you do with them? Organizing, sorting, and editing photos can be a fun way of interacting with your images, or it can be a real chore.

With film, the prints and negatives were often stored in a shoebox, never to be seen again. With digital photography and with a little time and effort, you can access your photos again and again.

This chapter will help you get photos into your computer, and then edit and organize them so that you can access them easily in the future.

Import Photos to Your Computer

So you have taken a lot of photos, and now you want to get them from your camera to your computer. That frees up your memory card for new photos, and it gives you access to your images on the computer so that you can optimize and enhance them, use them for e-mail, put them into a slide show, and much more. Once your photos are on the hard drive of your computer, you can do so many things with them. However, to start, you have to get them onto the computer.

The Computer Is like a Filing Cabinet

Your photos may all be composed of electronic bits of information, but what you are really doing when you move photos from camera to computer is similar to putting them into a filing cabinet. The computer is a storage place, and you start using it that way by moving your photos into filing folders in the computer's hard drive, the "filing cabinet."

Download from a Camera

Getting your images from camera to computer is pretty easy. Most cameras come with a special USB cord that attaches to the camera and then to a USB port on the computer. Unless you have a very old computer, it will recognize your camera and its image files. You can then move the photos onto the computer's hard drive.

Download from a Memory Card Reader

Another way of downloading images is by using a memory card reader. This device plugs into a USB or FireWire port on your computer, and then you take your memory card from your camera and put it into the card reader. The computer recognizes the image files on your memory card and allows you to transfer them to the computer.

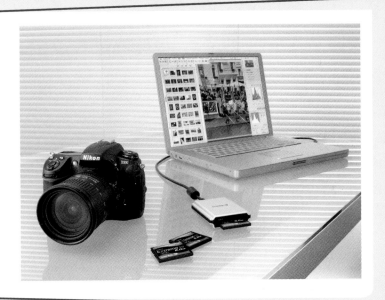

Advantages of a Memory Card Reader

A memory card reader offers a number of advantages over downloading from a camera. First, it is usually faster. Second, it needs no power and so it cannot run out of power while downloading, which can happen to a camera. Third, it takes up little space. Fourth, you never have to search for that "lost" camera cord.

Organize Photos on a Hard Drive

Once you get a camera or memory card hooked up to the computer, you are ready to copy your image files to the computer. How you organize your hard drive is like how you organize your filing cabinet. Better organization means you will be able to find your photos more easily in the future. The names of folders used in this task could be used, or you could create your own names. The important thing is to create names and a folder structure that works for your photos.

Organize Photos on a Hard Drive

Set Up Folders for Your Photos

Keeping in mind the filing cabinet analogy, you can set up folders in your computer specifically for your photos. How you set up these folders should relate to how you file and find anything in folders so that you are comfortable with the system. Create folders and subfolders with names and categories that help you find your photos more easily.

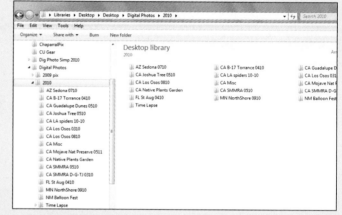

Start with Pictures

● Your operating system has a folder called Pictures or something similar already created in your Documents folder or libraries.

❶ Open the **Pictures** folder and create a new folder by right-clicking in the blank area. A menu appears. Move your cursor over **New** and then select **Folder** in the menu that appears.

❷ Name that folder **Digital Images**.

This will be the home for your photos.

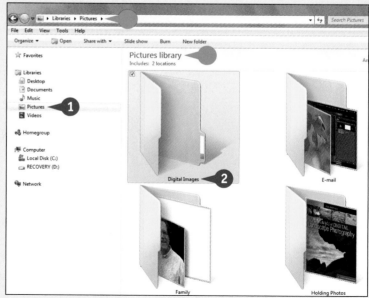

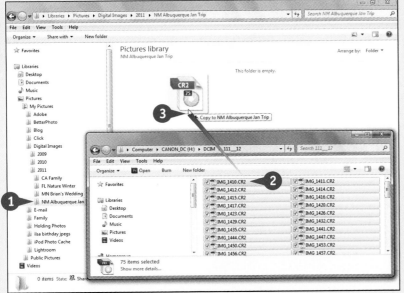

Create Your Own Folders for Events

Once you have a Digital Images folder, you can create specific folders as needed inside that folder to help keep your photos organized.

1 Create a new folder.

This example creates a folder for the year.

2 Open the new folder and create subfolders for specific events or times you took pictures.

In this example, the 2011 folder contains folders CA Family, FL Nature Winter, and MN Brian's Wedding.

Click and Drag Photos

Once you have specific folders set up, dragging and dropping photos from your memory card or camera into those folders is easy.

1 Open or create a new folder where you want to place your photos.

2 Open the folder from your memory card that has the photos and select the photos.

3 Drag them all into the new folder.

What is the best way to organize photos on a hard drive?

You need to create a system that you can work with and that you are comfortable with. It starts with the location of your folders. Put them in a unique folder on your desktop, in a special folder in Documents, or in a folder you create specially for your images on your hard drive. Then set up a structure of folders within that folder that also matches how you like to think and work.

Back Up Photos on a Second Drive

Think about the hard drive where your photos are kept. You often hear the saying, "It is not *if* your hard drive will fail, but *when*." Hard drives do indeed fail, and if all your photos are on that drive when it fails, they will be lost forever unless you have them backed up. The best way to back them up is with another drive. Protect your photos by doing this regularly, and be sure that drive is separate from your computer. If you simply have a second hard drive in your computer, you may lose everything if the computer has problems.

Back Up Photos on a Second Drive

External Hard Drives Give Protection

External hard drives simply plug into a USB or FireWire port on your computer and instantly offer you a lot more storage, just like adding extra filing cabinets. High-capacity drives are very affordable. Be sure you have enough gigabytes to handle your photos now and in the future.

Click and Drag for Simple Backup

1 Open your external hard drive.

2 Create a backup folder with a set of subfolders just like your Digital Images folder.

3 Click and drag your photos from the Digital Images folder on your computer's hard drive to the external drive by dragging a new folder into the right folder in the backup area.

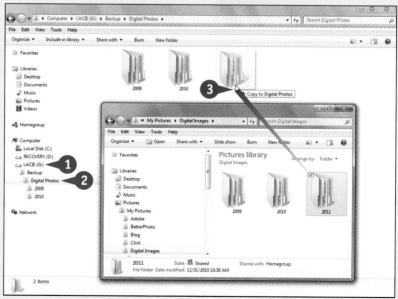

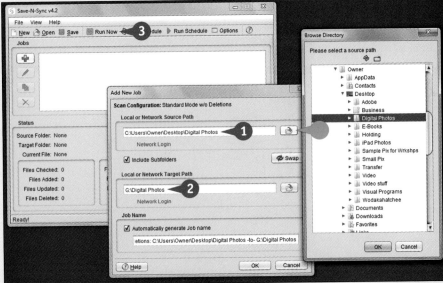

Backup Software Can Help

Backup software automates your backup. There are many software programs that do this, such as Time Machine on a Mac or the Save-N-Sync program from Composite Ideas.

1 Choose the source folder.

● You can click the folder icon (📁) to find your original folder of images.

2 Choose the target folder. This is the new place on your backup hard drive. Use the same names for folders there as in the original folder to make the software run more efficiently.

3 Click **Run Now** to start.

Try an Additional Hard Drive Away from the Computer

If you have some really important photos, you might want to keep them on a hard drive some distance away from your computer and its external drive. You can copy photos to an external hard drive for this purpose, and then move that drive someplace safe away from your original system.

Simplify It

How can I rename photos? The original names are not helpful.
Photoshop Elements, an image-processing and editing program, does not display filenames by default, so if you are working there, you do not have to rename images. But you may want your photos to have names on the hard drive that make more sense than img0122, and you may want to rename a whole group of photos. You can do this in Photoshop Elements. Select a group of images that you want to rename in the Organizer module. Click **File** and then click **Rename** to open the Rename dialog box. The name you type completely renames all selected photos.

Using Photoshop Elements to Organize Photos

Photoshop Elements has a basic organizing module that can help you keep track of photos on your computer. Having specific, named folders always helps, but then you have to open and search individual folders to find a specific photo. By having them organized in some way, you can find exactly what you need much faster. Photoshop Elements includes several ways of doing this in the Organizer module, such as using keywords, tags, and dates to help you find photos.

Using Photoshop Elements to Organize Photos

Photoshop Elements Starts with Date

1. Open Photoshop Elements Organizer.

2. Bring photos into the Organizer module by clicking **File**, **Get Photos**, and then **From Files and Folders**. In the resulting Get Photos dialog box, find the folder that Photoshop Elements needs to import. The program creates references to those files, but no file is actually moved.

3. Photoshop Elements starts organizing by using the date the image was shot, a date the camera imbedded into the file.

Rate Your Photos for Sorting

1. Under each photo thumbnail is a set of five stars. You can rate your photos to sort them into groups by clicking the stars under the photos; for example, best images could have five stars, whereas those to be deleted could have one star. You can also click a photo and use the numbers 1 to 5.

2. Sort your images by star rating by clicking the stars at the top right of all photos and using the drop-down menu next to them to control what is seen.

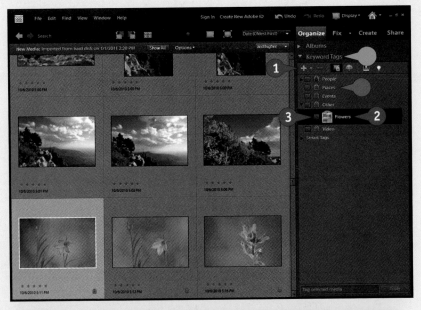

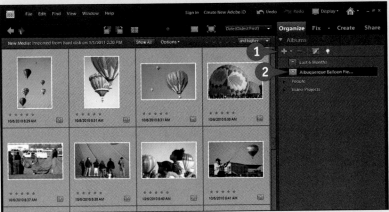

Add Keyword Tags to Help You Search

● Keyword Tags includes preset tag categories for keywords that Adobe has chosen.

● Drag these tags onto your photos to tag them.

1 Create your own keyword tags by clicking the plus sign (⊞).

2 Type a keyword name in the resulting dialog box, and put this into an appropriate category. You can have separate keyword tags or you can put them into categories.

3 If you click the check box at the left of each tag, you see only photos that relate to that keyword.

Group Photos into Albums

1 Create albums for specific purposes. Create albums by clicking ⊞ at the top of the right panel. Make an album for a group such as family or church or for locations or other specific categories. Do not choose the Backup/Sync option unless you have a photoshop.com account. Then click and drag photos into these albums, or albums onto photos.

2 Clicking the album icon reveals the photos in it.

Simplify It

Remembering all the different options can be hard. Is there anything that can help?
Absolutely! Try the right mouse button. Both PCs and Macs can use right-click buttons, and having a mouse with that capability is important. Right-click specific parts of the screen and you get a context-sensitive menu. For example, if you are not sure about something regarding a photo, try right-clicking it, and the menu will be about photos. You get a series of options for every place you click on the interface, but the options are limited and apply to the area in which you are interested.

Edit the Good from the Bad

Although rating photos and separating good photos from ones that you want to delete is useful, many photographers do not do this because the process is intimidating. What if they erase the wrong photos? Yet, if you do not get rid of photos, you will clutter your hard drive with excess photos that take up space and also make it harder to sort through those photos. It is very time consuming and difficult to try to put huge numbers of photos into categories.

Get Rid of Exposure Problems

First, look for exposure problems. Overexposed, washed-out photos are never going to look right, no matter how much time you spend working on them. Underexposed, overly dark photos are also a problem because they become filled with noise and are always frustrating to work on. Get rid of these images.

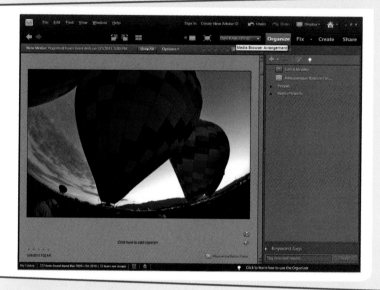

Watch for Focus Problems

No matter how much you like that photo from your last trip, if it is out of focus, you will never really fix it and it will never be a satisfying image. Blurry photos from the wrong shutter speed are difficult for most people to view. Delete photos like these because they are just going to create problems for you.

Remove the Shots with Bad Timing

Everyone takes photos that show bad facial expressions, with objects you never saw blocking the view on one side of the composition, or with the subjects in awkward positions. If you keep these photos, you will always be making excuses for the shots. Delete them because they will never be effective photos.

If You Do Not Like a Photo, Delete It

Many photographers hang onto certain photos because they think they might need them someday. They are usually shots of a favorite person, pet, or location, but the shots do not flatter the subject. Or for whatever reason, you just do not like them. Trust your intuition and get rid of the photos because you are unlikely to ever really use those images.

Chapter 11

Basic Adjustments with Photoshop Elements

Photoshop Elements is a program designed to help you adjust your photos on your computer. Photoshop Elements is made to be photographer-friendly, yet it is also quite powerful in what it can do. Still, being able to use the program at its best does take some practice. In this chapter, you learn some key ways of working with the Edit features of the program.

In addition, the developers of Photoshop Elements have included many helps built into the program, as well as an excellent Help menu. Look for text in many dialog boxes that helps you make decisions on what to do.

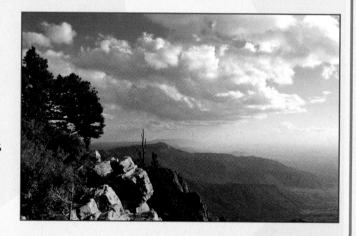

Crop Your Photos for Better Images

Often you have a good start to a photo, but the image as a whole is not quite right. There may be too much space around your subject so that you cannot see details as well as you would like. Or perhaps some distracting element snuck into a corner of the photo, such as someone's foot or hand, which just does not belong in the image. And there are always those photos that look crooked and need to be straightened. Photoshop Elements lets you take care of all of those problems.

Crop Your Photos for Better Images

Find the Crop Tool in the Toolbox

● Use the Crop tool (▣) to crop your image to show only the part you want. The Crop tool is located at about the middle of the Toolbox. This tool looks like a traditional designer's physical crop tool.

Drag a Box around Your Subject

① Use the Crop tool like a cursor. Click at the upper left corner of the part of the photo you want to keep.

② Drag diagonally through the desired area. You do not need to be precise because you can then click and drag the edges in and out as appropriate until you get the cropped area you need.

③ Click the green check mark (✔) to accept the change, or just press Return or Enter. To cancel your crop, click the red circle/slash icon (◯) or just press Esc.

Experiment with Cropping

● The outside of the crop box dims to emphasize what you will keep after cropping. Try different amounts of cropping before committing to the crop. Even if you do commit and you do not like it, you can just press ⌘/Ctrl + Z to undo it, which takes you back to the original photo. Then try a new crop and see how the photo changes.

Crop to a Specific Size

① Click the Aspect Ratio drop-down menu on the toolbar to display a list of some standard photo sizes.

② You can also type specific sizes in the Width and Height fields.

● Remember that you can reset all of these settings by clicking the arrow at the far left and choosing **Reset tool**.

Simplify It

When should I crop to a specific size?
Generally, it is best to crop to a specific size at the end of your work in Photoshop Elements, not at the beginning of the process. Crop out problems at the beginning so you do not have to deal with them as you work. If you crop to a specific size at the start, you may be limiting your sizing options later. You may discover that you want to have sizes with different proportions. In that case, it is best to work with a master image that has had minimal cropping done to it.

Fix Crooked Horizons

Sooner or later, every photographer gets crooked photos. The most common of this type of problem is the tilting horizon. For example, the line of an ocean, lake, or distant horizon appears to take an unrealistic downward slope. Or you may find that your kids have a distinctive lean in the photo that is not normally the way they stand. When everyone shot with film, you just had to live with this problem. Luckily, you no longer have to; crooked photos are very easy to fix in Photoshop Elements.

Fix Crooked Horizons

Rotate the Crop Box

① Create a crop box around the area of your photo that you want to keep. Position your cursor outside of the crop box. The cursor turns into a curved arrow (⤸). By clicking and dragging that curved arrow, you can rotate the entire crop box to adjust and straighten your photo.

② Click the green check mark; Photoshop Elements makes the crop and straightens the photo at the same time.

Line Up Horizons with a Straight Line

Horizons need to be straight and horizontal. Your crop box has two straight, horizontal lines.

③ Move the top or bottom line of your crop box close to your tilted horizon. Click outside the box to rotate the crop box to match the line and the horizon.

④ Drag the edges of the box until you get the full crop you want, and click the green check mark.

166

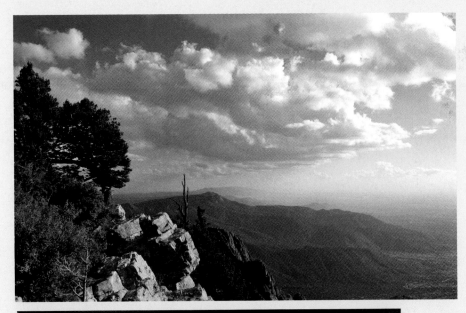

Your horizon is straightened.

Use Custom Rotation for Precise Control

Sometimes it is tough to get the horizon or other lines exactly right. Photoshop Elements offers a control for very precise adjustment.

1 Click **Image**.

2 Click **Rotate**.

3 Click **Custom**.

The Rotate Canvas dialog box opens.

4 Type a number for the rotation. At first, you may have to guess, but if you make a mistake, you can just undo and try again. You have to crop the edges when you are done.

Fix Photos in the Wrong Orientation

Most cameras today record orientation information with the photos so that they come out correctly horizontal or vertical. However, sometimes that does not work. You can correct that very simply.

1 Click **Image**.

2 Click **Rotate**.

3 Click **90° Left** or **90° Right** as appropriate for your photo.

Fix Gray Photos

Often photos come from a digital camera with a distinct gray cast to them. They do not have the lively contrast and color that photographers have come to expect from film. This is not a digital shortcoming, but simply a way that camera designers have worked to hold detail in dark areas. You simply have to adjust the photo to bring that contrast and color back. This can make an especially big difference in a print. With any photo that you really care about and from which you want larger prints, always check these adjustments.

Fix Gray Photos

Before photo straight from camera.

Try Auto Smart Fix

Images coming straight from the digital camera are not always adjusted properly. Smart Fix is a one-step way to correct this.

① Click **Enhance**.

② Click **Auto Smart Fix**.

The image in the figure has been corrected with Auto Smart Fix. If this does not give you a good image, simply undo the change with ⌘/Ctrl + Z and try another control.

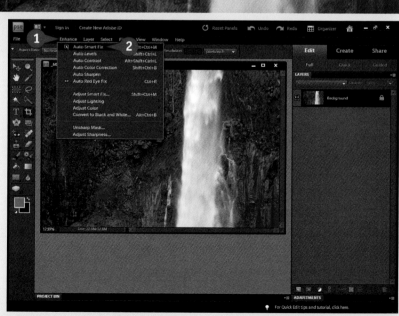

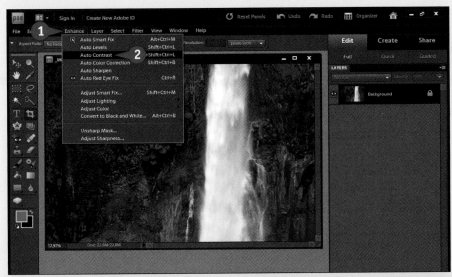

Try Auto Contrast

1 Click **Enhance**.

2 Click **Auto Contrast**.

The image in the figure has been corrected with Auto Contrast.

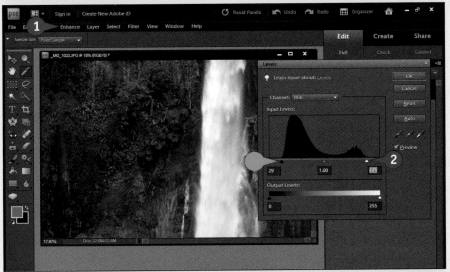

Use Levels for More Control

1 Click **Enhance**, click **Adjust Lighting**, and then select **Levels**.

The Levels dialog box opens.

● Look at the black and white sliders under the graph, which is called a *histogram*.

2 On most photos, you can move the black slider to just under the upward slope of the graph at the left, and the white slider to just under the upward slope at the right. This is a good adjustment to start with on most photos.

Black Is Subjective, White Is Limited

● The black slider in Levels is very subjective. You can get dramatic results as it moves to the right.

● The white slider, though, quickly washes out highlights if you move it too far to the left.

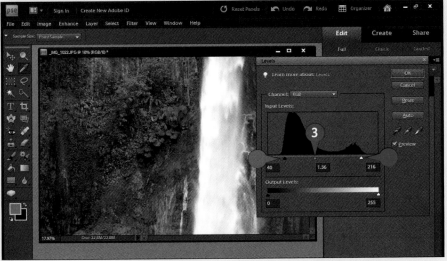

3 Use the middle slider to adjust the overall brightness of the image.

Make Dark Photos Brighter

As good as digital camera metering systems are, they never make every exposure perfect. Sometimes your photos are too dark and you need to brighten them. Or you have a photo that gets too dark from the Levels adjustments you made in the previous section. It may seem logical to use the Brightness/Contrast feature, located in the Enhance menu, but this control is very heavy handed and not appropriate for most overall adjustments. Photoshop Elements has controls that can make your photo look much better than that. Do not be afraid to try any of these and compare results. Just undo what you do not like with ⌘/Ctrl + Z.

Make Dark Photos Brighter

Before photo straight from camera.

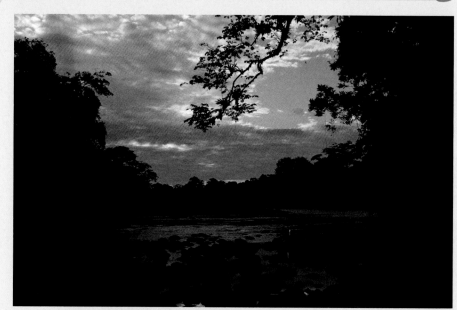

Try the Auto Controls

1 Sometimes for a dark photo, all you need to do is use the Auto Smart Fix command in the Enhance menu. This can really help with very dark and underexposed photos and was used in the figure shown here.

● You can also try Auto Levels in the same menu. Both commands work, but they affect colors differently. You may find that you need one command for one photo, and the other command for another.

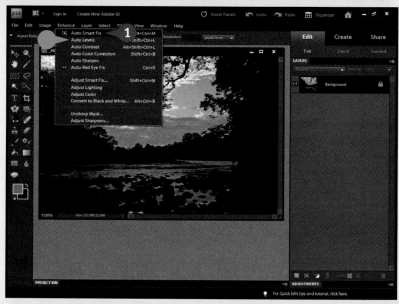

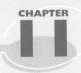

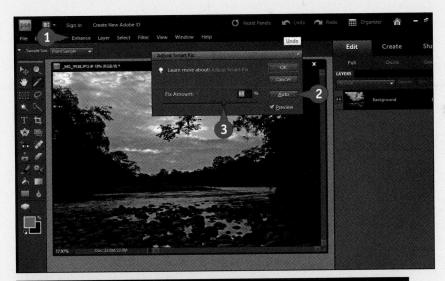

Use Adjust Smart Fix

You can adjust an automated control.

① Click **Enhance** and then click **Adjust Smart Fix**.

② In the Adjust Smart Fix dialog box, click the **Auto** button.

③ Move the **Fix Amount** slider to get the right amount of change.

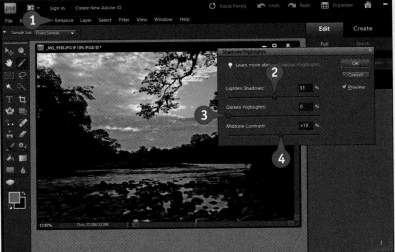

Try Shadows/Highlights

You might find that just the shadows are too dark.

① Click **Enhance**, click **Adjust Lighting**, and then click **Shadows/Highlights**.

② In the Shadows/Highlights dialog box, adjust dark areas with the **Lighten Shadows** slider.

③ Correct bright areas with the **Darken Highlights** slider.

④ Fix midtones with the **Midtone Contrast** slider.

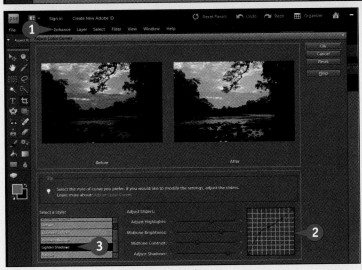

Experiment with Color Curves

You can use Color Curves when photos are just a little too dark.

① Click **Enhance**, click **Adjust Color**, and then click **Adjust Color Curves**.

② In the Adjust Color Curves dialog box, adjust the sliders to brighten or darken specific tones.

③ You can also try one of the preset adjustments.

Correct Color Easily

Color is an important part of photography, so when a photograph's color is off in some way, people notice this. In the days of film, this was always a problem, especially when skin tones went bad or hair changed color because of fluorescent lights. This is no longer true. You can correct problem colors quite easily in Photoshop Elements and make any subject look its best under all sorts of light.

Correct Color Easily

Before photo straight from camera.

Try Auto Settings to Correct Color

1 When your photo has a slight color bias, you can click **Enhance**, and then click **Auto Color Correction**.

Photoshop Elements examines all the colors in your photo and tries to balance them.

● If Auto Color Correction does not work, undo it and try **Auto Smart Fix** or **Auto Levels**.

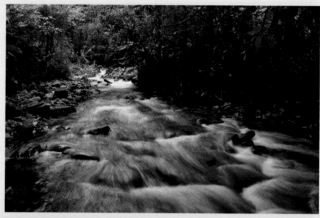

Remove a Color Cast

1 Remove an unwelcome color cast in your photo by clicking **Enhance**, clicking **Adjust Color**, and then clicking **Remove Color Cast**.

The Remove Color Cast dialog box opens.

2 Click something white, gray, or black that should be neutral in color.

Photoshop Elements removes the color cast. You may have to click in multiple places to get it right.

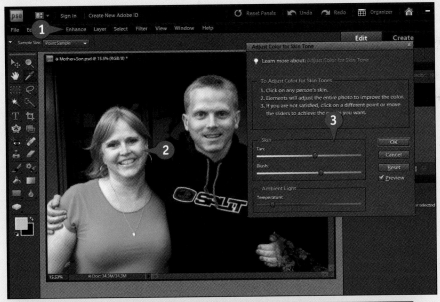

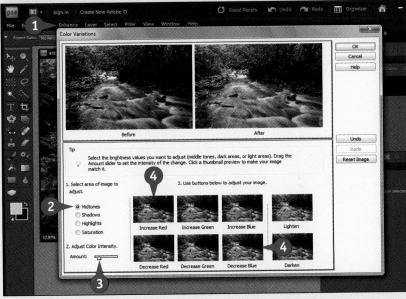

Adjust Skin Color

Fix problem skin color with the Adjust Color for Skin Tone feature.

1 Click **Enhance**, click **Adjust Color**, and then click **Adjust Color for Skin Tone**.

2 In the Adjust Color for Skin Tone dialog box, position your cursor over the person's skin, and click.

3 The Skin and Ambient Light sliders become active so that you can adjust the skin color.

Warm Up a Photo

In general, photos look better warmer than cooler. You can use the Color Variations feature to warm up a photo, as well as to change overall color.

1 Click **Enhance**, click **Adjust Color**, and then click **Color Variations**.

2 In the Color Variations dialog box, select **Midtones**.

3 Move the **Color Intensity** slider to the left to lower the intensity.

4 Click **Increase Red** and **Decrease Blue** to warm up the photo.

Simplify It

Why should I be concerned about black in a color photo?
Printers, your monitor, and other ways of displaying photos all have the capability of showing a solid black tone. If your image does not have that solid black, your photo will never use the full range of color and tone possible from that display. The result is that your image will look gray and less contrasty and have less-than-satisfactory color. Some photographers refer to this as "setting the blacks" because you are changing the black tone of many individual dark areas across the photo.

Try Black-and-White

Black-and-white photography used to be the most common way to take pictures. It has a very long history in photography, but it nearly disappeared when color photography became popular. Today, black-and-white is enjoying renewed interest. Because it is no longer common and because it does not show the world as realistically as color, many photographers use it as a more artistic medium. Changing color to black-and-white is very easy in Photoshop Elements.

Try Black-and-White

Try Remove Color for Simple Conversions

1 Click **Enhance**.

2 Click **Adjust Color**.

3 Click **Remove Color**.

The Remove Color feature is very limited in its results, but it is fast and easy.

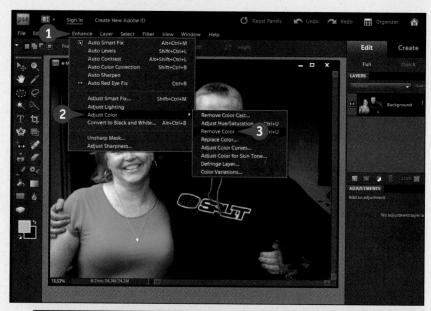

Remove Color is a simple way to convert color to black-and-white. There are no sliders or options; you just select it and it works. Use this method for images that do not have a lot of important colors or that have good contrast from light to dark.

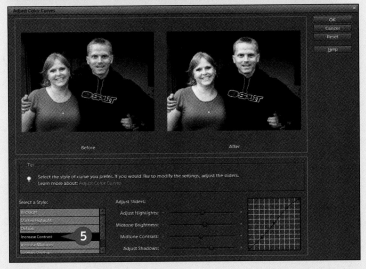

Better Conversions Come from Convert to Black-and-White

1 Click **Enhance**, and then click **Convert to Black and White**.

2 The resulting dialog box gives you a whole set of controls to help you change colors into tones of gray.

3 Try the Select a Style list for specific conversion results.

Convert Colors into Contrasting Tones of Gray

Contrast is a critical part of black-and-white photography. Green and red are very different, but they can look the same in black-and-white.

4 Try changing the **Adjust Intensity** sliders to affect how the colors red, green, and blue are changed into lighter or darker tones of gray.

Adjust Contrast of the Black-and-White Image

Because contrast in a black-and-white photo is so important, you should make an additional adjustment after converting from color. Often, all you need is the Auto Contrast or Auto Levels feature, found in the Enhance menu.

5 In the Adjust Color Curves dialog box, try changing the contrast by using the **Increase Contrast** style and by adjusting the shadow and midtone sliders.

Size the Picture for Printing

The size of your photo depends on the megapixels of your sensor. This size affects how large you can make a print. Cameras today are perfectly capable of making large prints that easily match anything that 35mm film can do.

There is a certain range of print sizes that are possible with the pixels that come from your sensor. You can then make photos larger or smaller by having Photoshop Elements change the number of pixels in the image file.

Size the Picture for Printing

Choose a Printing Resolution

Find out how large or small you can make your print based on the original pixels of your image.

1 Click **Image**, click **Resize**, and then click **Image Size**.

2 Be sure that the **Resample Image** option is unchecked.

3 Type **200** ppi for the resolution, and note the size of your print in the Document Size area. Type **360** ppi. These printing resolutions work for all photo printers, and the size dimensions that result show you how large or small you can make your print based on existing pixels.

Choose a Printing Size

4 Specify a size for your print in the Document Size area.

● Ensure that the resolution is between 200 and 360 ppi.

5 Click **OK**.

You cannot make specific sizes for a print here because you need to size all sides proportionately. If you need a specific size, size one side to what you need, and crop when you have finished sizing.

Enlarge an Image File

Your photo might not be as large as you want, even when you use a resolution of 200 ppi.

⑥ In the Image Size dialog box, check the **Resample Image** option.

● Leave the resolution at 200 ppi.

⑦ Specify a key width or height that you need. The other dimension changes automatically.

⑧ In the Resample Image drop-down menu, choose **Bicubic Smoother** to add pixels for enlargement.

Shrink an Image

You may also find that your photo is not as small as you need, even when you use a resolution of 360 ppi.

① Repeat Steps **1** to **5**.

② In the Image Size dialog box, check the **Resample Image** option.

● Leave the resolution at 360 ppi.

③ Type the key dimension needed.

④ In the Resample Image drop-down menu, choose **Bicubic Sharper**.

Simplify It

Which photos should I resize?
Not all photos resize well, so save yourself some trouble and resize only photos that look good resized. This is influenced by a number of factors. An over- or underexposed photo frequently does not look good at larger sizes. If your photo has a lot of noise, it often resizes poorly. And finally, blur from camera movement sabotages the resizing of most images, so do your best to get the image sharp when you take the picture.

Size Photos for E-mail

Adding a photo or two to an e-mail is pretty easy to do. It is also a little too easy to add image files in their original size, which clogs up people's mailboxes and slows down their computers. Avoid annoying your friends and family. Resize your photos to a proper size for e-mail. This allows you to send the images with fewer problems, and your recipients will be happier to get photos from you. This is especially important if your recipient does not have a broadband connection to the Internet.

Make Your Photos Small

1 Click **Image**, click **Resize**, and then click **Resize Image**.

The Image Size dialog box opens.

2 Check the **Resample Image** option, and select **Bicubic Sharper** in the Resample Image drop-down menu.

3 Type **100** in the Resolution field.

4 For the long side, specify either a width or height in the Document Size section. The short side changes automatically to reflect this amount.

This example uses a width of 8 inches, which is a large viewable image for e-mail. If you need smaller photos, you can use 6 inches.

Printable Files Can Be E-mailed

If you want your recipient to be able to make a print, you need to size the image a little differently.

5 Type **150** in the Resolution field.

6 Use a size of **6** inches for the width or height of the long side.

This gives an approximately 4-x-6-inch print at an acceptable resolution for printing, but in a file size appropriate for an e-mail.

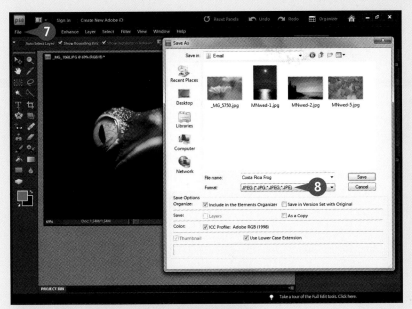

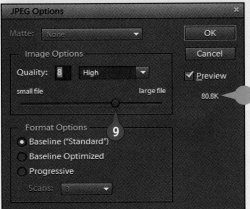

Save Your Photos as JPEG Files

7 Click **File**, and then click **Save As**.

The Save As dialog box opens.

8 Save the photo as a JPEG file. JPEG compresses your image file so that it becomes much smaller and easier to e-mail.

Check Your File Size

The JPEG Options dialog box opens.

9 Choose a compression level for JPEG using the **Quality** slider. Use middle or high numbers whenever you can.

● To keep your e-mail small, try to keep your file size 200KB or less. If you are sending many photos, keep the maximum size lower.

Why not just attach my camera's photo files to an e-mail?
Digital cameras today have very large image files, even when you are using compressed files in the JPEG format. You can easily have a single file 1 to 2MB in size. That is a very big file for e-mail and will frustrate a lot of people who get it. It may be easy for you to attach and send, but not so easy for the recipient to deal with on the other end. Keeping your files small for e-mail makes your recipients much happier to get photos from you.

Sharpen the Image

Your camera probably already applied some sharpening to your image file. Still, most of the time when you work on a photo, you need to sharpen it after you have sized it for printing. Sharpening is designed to bring the most detail out of your image file, based on the original sharpness of the photo. It is not designed to make a fuzzy or blurry photo sharp. Sharpening blurry images usually makes them look worse.

Try Auto Sharpen

1 Photoshop Elements has a number of sharpening tools that you can use to good effect. However, the one-click Auto Sharpen feature in the Enhance menu does such a good job that you often need little else.

● If needed, magnify your photo with the **Zoom** magnifier tool (🔍) first to zoom in on important details.

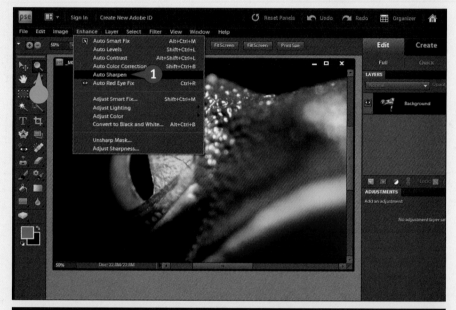

For Precise Control, Use Unsharp Mask

You can use the Unsharp Mask feature when you need to control sharpening carefully.

1 Click **Enhance**, and then click **Unsharp Mask**.

The Unsharp Mask dialog box opens. This control lets you adjust:

2 Amount or intensity of the sharpening.

3 Radius or width of the sharpening.

4 Threshold or how noise is sharpened.

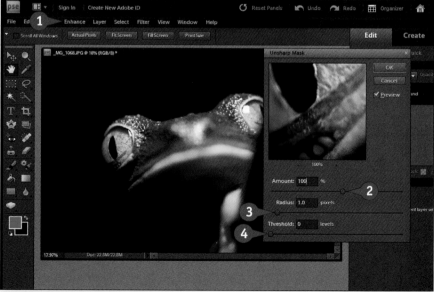

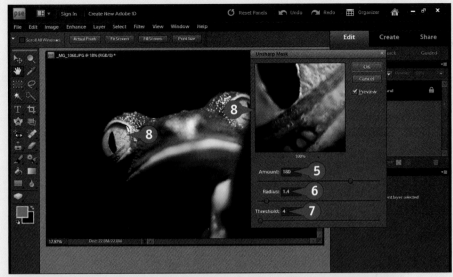

Numbers You Can Use

Photographers use a lot of formulas for Unsharp Mask adjustments, and they all work for different purposes. Be careful not to sharpen too much.

⑤ Try a range of **120** to **180** for Amount, depending on the subject.

⑥ Try **0.8** to **1.5** for Radius, depending on the size of your photo.

⑦ Try **3** to **6** for Threshold, depending on the amount of noise in areas such as the sky and out-of-focus tones.

⑧ Click the main image with your cursor to set what is seen in the small preview.

Try Adjust Sharpness

The Adjust Sharpness feature is an advanced smart-sharpening tool.

① Click **Enhance**, and then click **Adjust Sharpness**.

The Adjust Sharpness dialog box opens.

② Specify Amount and Radius settings, just like Unsharp Mask. Because it does not have a Threshold setting, Adjust Sharpness is not as good with images that have a lot of noise.

③ Check the **More Refined** option to make edge sharpness look better.

How much sharpening can I apply?
Images coming from a sensor must be sharpened. This is not about your lens or focusing — it is about how digital sensors work. Sharpening is needed to bring out the original sharpness of your lens. Most cameras do sharpen JPEG files to a degree. Be very careful of oversharpening photos. Sharpening should be applied to give a good-looking sharpness but not a harsh sharpness. Sharpening can only be used to get the most from a photo that was sharp to begin with. It cannot make a fuzzy photo look sharp.

Chapter 12

Additional Controls with Photoshop Elements

Photoshop Elements is a very powerful program. You do not have to know everything about Photoshop Elements to get the most from it, but you do need to know those tools and adjustments that work best with your subject matter, for your specific photographic needs. You cannot learn those things by simply reading a book. You have to practice and see what works best for you.

You can learn to use Photoshop Elements by working with your own photos as you try out the ideas presented here. That experience, including both your successes and failures, will help you use the program better and faster. Work with your good and your bad photos, so that you can get to know the program's tools.

Using Selections to Isolate Adjustments

When working on a photo, you will often notice that only part of the photo needs to be adjusted, not the whole image. It would be great to be able to adjust only that part and nothing else. Fortunately, with selections, you can do exactly that. For example, you can make something darker or lighter, or adjust its color, in isolation from the rest of the photo. Selections create a kind of fence around a part of your photo, allowing adjustments to occur inside that fence, but never outside. You can press ⌘/Ctrl + D to remove a selection.

Using Selections to Isolate Adjustments

Shape Selections and How Selections Work

1 Near the top of the Toolbox, you will find selection tools such as the Rectangle/Square and the Ellipse/Circle marquees. Click and hold the icon to see both tools.

2 Select a tool, and then click and drag the corresponding shape in the photo.

3 You can now change anything inside the selection without affecting the rest of the image.

Try the Polygonal Lasso

1 Next to the shape selection tools are the Lasso selection tools: Freehand, Polygonal, and Magnetic. Click and hold the icon to see them.

2 With the Polygonal Lasso tool (⬚) selected, click from point to point around a shape. Back up with `Backspace` or `Delete`.

3 Finish by clicking the start point.

4 Now you can precisely define where your adjustment occurs.

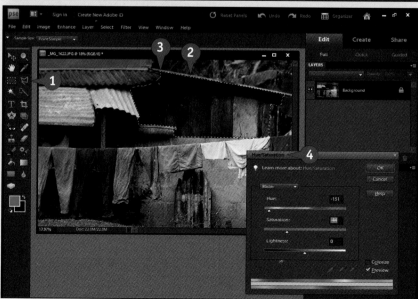

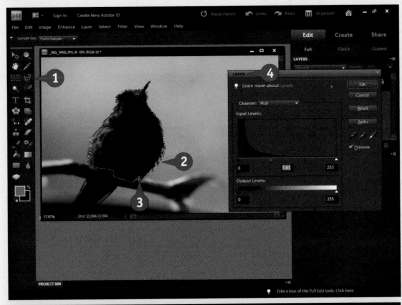

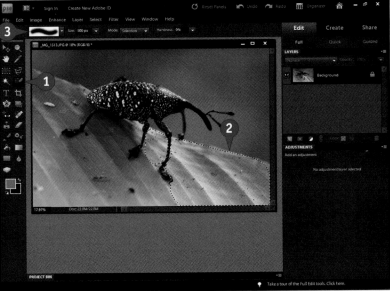

Use the Magnetic Lasso tool with Strong Edges

1 Use the **Magnetic Lasso** tool (⬚) to automatically find edges of shapes when edges strongly contrast.

2 Click near an edge, and then position the cursor near that edge; the magnetic feature finds the edge for you.

3 Finish by clicking the start point or by double-clicking.

4 You can now change anything inside the selection, such as the brightness of an image with Levels, without affecting the rest of the image.

Make Quick Selections

1 Use the **Selection Brush** tool (⬚) for another automated, easy-to-use selection tool.

2 With the Selection Brush tool, you literally brush a selection over a photograph.

3 Change the brush size in the top toolbar to best fit your subject.

You can now change anything inside the selection without affecting the rest of the image.

Simplify It

Is the Magic Wand an automated selection tool, too?
Yes, the Magic Wand tool (⬚) creates a selection based on areas of similar color and tone when you click one area. Using it is fairly simple. You select the tool from the Toolbox, and then position your cursor over your photograph. Find an area of similar tone or color, and then click. This then creates a selection based on that color or tone. Change **Tolerance** in the options toolbar to get more or less of the area selected by typing larger or smaller numbers respectively. Use **Contiguous** to select based on tones and colors that are contiguous or together. Uncheck **Contiguous** to select similar tones and colors throughout the whole photo.

Modify Your Selections

You can modify both your selections and how you work on a selection in ways that will make selections easier for you. You can build up a selection with a series of smaller selections, and you can change the edge so that any changes blend better. Selections can take a lot of time and make your work more tedious; these tips will help you work with selections faster and more efficiently. Remove any selection by clicking Select and then choosing Deselect or by pressing ⌘/Ctrl + D.

Add to a Selection

As you make a selection, you will often find that you cannot select the whole area at once.

1. By pressing Shift as you use your selection tool, you can add to a selection.

2. You can also click the **Add to Selection** icon (▣) in the toolbar so that you can add to a selection.

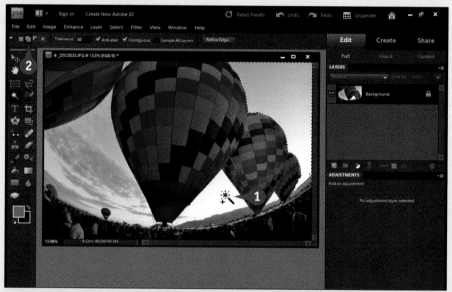

Subtract from a Selection

Conversely, you may find that although the selection contains what you want, it catches too much of an area. You can change the selection without starting over.

1. By pressing Option/Alt as you use your selection tool, you can subtract from any selection.

2. You can also click the **Subtract from Selection** icon (▣) in the toolbar to subtract from a selection.

Combine Selection Tools

Sometimes you will find it easiest to create a selection one step at a time, adding a little here and subtracting something there.

1 Try using the **Magic Wand** tool (⬛) on an area that contains similar colors and tones.

● This example uses the tool on a sky, with the **Contiguous** option unchecked to get the sky around the gondolas of the balloons. However, it picked up extra blue in the eyes of the kangaroo balloon.

2 Use the **Lasso** tool (⬤) with Option/Alt to remove unwanted selection areas.

Blend Your Selection Edge

By default, selections have a rather hard edge that does not blend well into the adjacent areas of a photograph. You can make your edges blend with feathering.

1 Click **Select** and then choose **Feather**.

The Feather Selection dialog box opens.

2 Use a small number for edges that need a sharper edge, and a large number for edges that need to gradually change from one area to another. Specific numbers will vary depending on the content and size of your photo.

Increase Color Saturation without Problems

When photographers first discover the Hue/Saturation feature, they often get carried away. This tool seems to magically transform dull colors into bright and vibrant colors. Unfortunately, that often means garish and unattractive photos. Also, overuse of this feature can result in more and very unattractive noise in an image. You can use this control effectively to give good color without garish results.

Increase Color Saturation without Problems

Go Easy on Saturation

The Hue/Saturation adjustment lets you change colors as well as their intensity.

① Click **Enhance**, click **Adjust Color**, and then click **Adjust Hue/Saturation**.

The Hue/Saturation dialog box opens.

② The Hue slider changes the colors.

③ The Saturation slider adjusts the intensity of colors. The Saturation slider is rather heavy handed; adjusting more than 10 to 15 points usually causes problems.

Change Colors Individually

The trick to using the Hue/Saturation feature is to make stronger adjustments to individual colors.

④ In the Hue/Saturation dialog box, click **Master** to get a drop-down menu of colors.

⑤ Choose a color; Photoshop Elements limits the adjustment of Hue, Saturation, or Luminance to just that range of color.

Tell Photoshop Elements Exactly Which Color to Change

6 Refine your color even more by moving your cursor out onto the photograph. The cursor changes to an eyedropper (✐).

7 Now position it over the color you want to adjust, and click once.

8 The color scales at the bottom of the dialog box shift to match that color so that changes are more specific to it.

Use a Selection to Further Limit Color Change

Even when you tell Photoshop Elements to restrict its color changes to a specific color range, those colors may appear throughout your photo.

9 Make a selection first to limit any change to a specific area.

10 Open the Hue/Saturation dialog box and adjust as described in Steps **4** and **5**.

Simplify It

I used to like the bright colors of Fujicolor film. Can I use Hue/Saturation to get those colors?
The answer is a cautious, "Yes, but..." Those colors come from more than saturation. The film had a strong black base and deep contrast, which increased the intensity of the color. You can get that with Levels by how you set the blacks and whites as described in the section "Fix Gray Photos" in Chapter 11. After that, use Hue/Saturation, but avoid using Saturation alone for more than 15 points adjustment. Then tweak individual colors as needed to get your colors bright and "colorful" like Fuji film.

Darken Specific Areas of a Photo

Ansel Adams is a name that most people recognize as one of the great landscape photographers. The wonderful black-and-white photographs of scenery he created are still popular today. One of the things he did in the traditional darkroom was to darken parts of a photo so that it was more balanced and better emphasized, plus it helped highlight the subject. You can do the same thing with Photoshop Elements, and you never need to find a darkroom!

Darken Specific Areas of a Photo

Look at Your Whole Photo

Take a look at your whole photo, and decide what areas are too bright.

① Find parts that look out of balance with the rest of the photo because their brightness attracts the viewer's eye away from your subject. These are the areas you want to darken, and you want to do this so that the changes blend well with the whole photo.

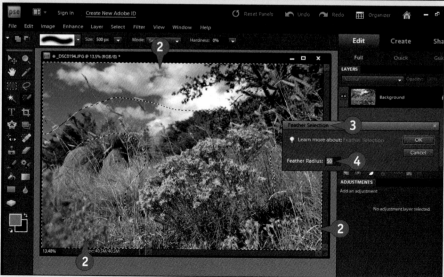

Select the Area for Darkening

② Select the area or areas that need darkening.

③ Open the Feather Selection dialog box so that you can feather and blend the edge.

④ If there is a strong edge, the feather can be only a few pixels. If there is no strong edge, then use a large feather to blend the change more — for example, 50 to 60 pixels or more.

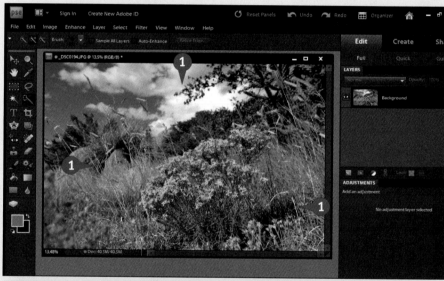

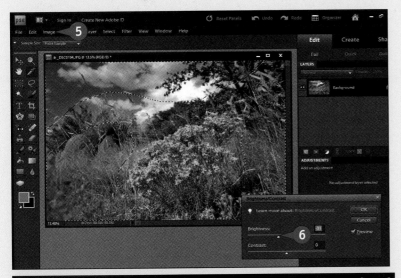

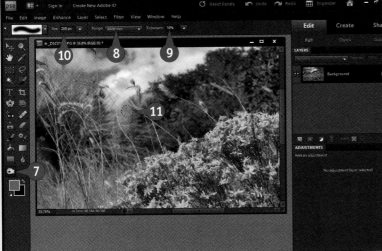

Use Brightness/Contrast for Darkening

5 Click **Enhance**, click **Adjust Lighting**, and then click **Brightness/Contrast**.

The Brightness/Contrast dialog box opens. In general, you should not use Brightness/Contrast for overall changes to your photo. For darkening, the Brightness slider gives a very good result.

6 Move the slider left until you like the change.

Use the Burn Tool for Small Areas

7 For small areas, choose the **Burn** tool (⬛) in the Toolbox. It is near the bottom and shares the same space as the Sponge and Dodge tools. If you do not see the Burn icon, then click and hold on the **Sponge** tool (⬛) to see it. If you want to work outside of a selection, you must choose **Deselect** in the Select menu.

8 Set the tool to a range appropriate to the tones you want to affect.

9 Use a very low exposure of **5** to **10** percent.

10 Use a soft brush sized for the area.

11 Paint over the area to darken it using multiple strokes.

Lighten Specific Areas of a Photo

Ansel Adams lightened parts of a photo to bring out detail in certain areas without making the whole photo lighter. After getting the overall image right, Adams would create wonderful, majestic photographs by selectively lightening and darkening the photo. He would sometimes spend days in the darkroom just perfecting the right proportion of light and dark areas. You can do the same thing with Photoshop Elements in considerably less time.

Lighten Specific Areas of a Photo

Look for Detail That Is Too Dark

Take a look at your whole photo, looking for where darkness is working against your image.

1 What places are too dark? You can brighten these areas, and you can do it in such a way that changes blend well with the whole photo.

Select the Area for Lightening

2 Select the area that needs to be lightened.

3 Open the Feather Selection dialog box to blend the edge.

4 If there is a strong edge, the feather should be very small, maybe only a few pixels.

If there is no strong edge, then use a large feather to blend the change more — for example, **50** to **60** pixels or more.

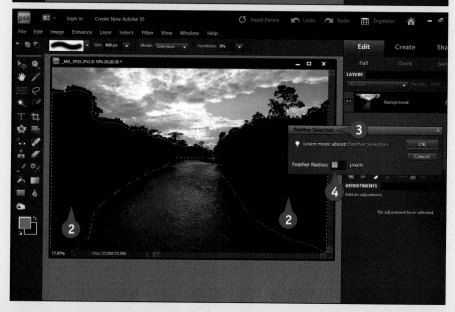

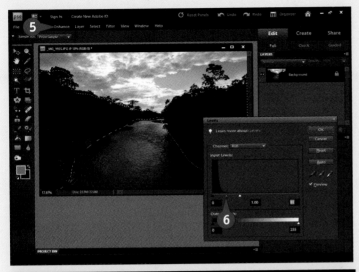

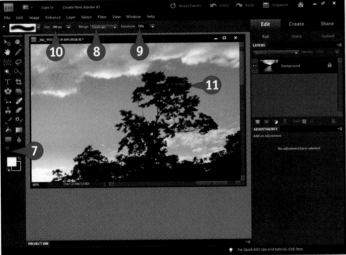

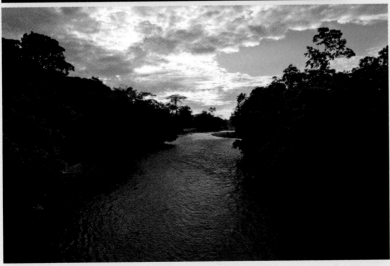

Use Levels for Brightening

⑤ For brightening, click **Enhance**, click **Adjust Lighting**, and then select **Levels**.

The Levels dialog box opens.

⑥ Move the right and middle slider to the left until the area looks properly brightened.

Use the Dodge Tool for Small Areas

⑦ Select the **Dodge** tool (⬛). This tool lightens an area, and shares space in the Toolbox with the Burn tool (⬛). Neither one works well for large areas because they tend to make the areas look blotchy.

⑧ Set the tool to a range appropriate to the tones you want to affect.

⑨ Use a very low exposure of **5** to **10** percent.

⑩ Use a soft brush sized for the area.

⑪ Paint over the area to lighten it in multiple strokes. If you want to work outside of a selection, you must choose **Deselect** in the Select menu.

Darken Edges for a Traditional Look

Ansel Adams often said that it was very important to darken the edges of any print to keep the viewer's eyes on the image. Darkening the edges really enlivens your photo and gives it a richness and depth that you cannot get in any other way. It took a bit of work in the old darkroom, but it is really simple to do in Photoshop Elements. You also have a lot of control over how dark you want the edges.

Darken Edges for a Traditional Look

Select the Inside of the Photo

1 Select the **Elliptical Marquee** tool (▦).

2 Make a selection that includes most of the inside of the photo.

While you have a selection tool active, you can also click inside the selection and move it around to a better place. The Polygonal Lasso tool (▧) can be used to make this sort of selection more precisely.

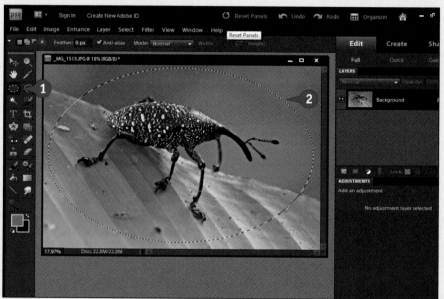

Give the Selection a Big Feather

You want the edge darkening to really blend nicely, and so you need a big feather to soften the selection edge.

3 To display the Feather Selection dialog box, click **Select** and then choose **Feather**.

4 Set at least a **130**-pixel feather (this could be as high as 200 pixels if you really need a gentle effect on a large photo). How much is really a matter of personal taste.

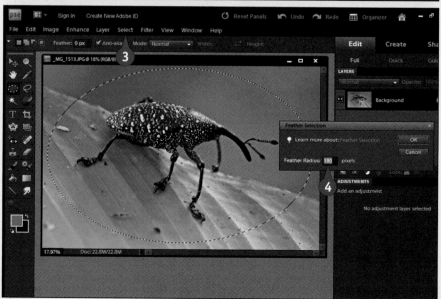

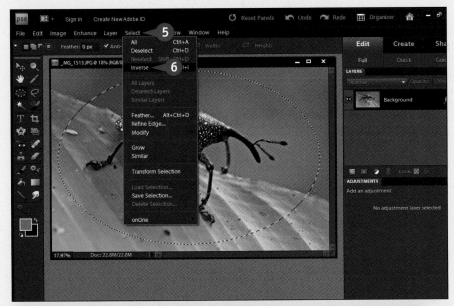

Invert the Selection

Right now, your selection is still making the center of the photo the active area. You need to invert this so that you can adjust the outside edges of the photo.

5 Click **Select**.

6 Click **Inverse**. This inverts your selection so that it now goes from the inner selection line to the outside edges of the photo.

Use Brightness/Contrast to Darken the Edges

7 Click **Enhance**, and then click **Adjust Lighting**.

The Brightness/Contrast dialog box opens.

8 Move the **Brightness** slider to the left. How much depends on the photo, but usually an amount of **20** to **30** works well. You can hide the selection line to better see the effect by pressing ⌘/Ctrl + H. Remember that you hid the line, though.

Simplify It

How dark should the edges be?

The quick answer to that is, "It depends." Ansel Adams would vary how strong this effect was depending on several factors: the brightness of the overall photo (lighter images usually need less); how dramatic you want the effect (it can range from subtle to very dramatic and still be "right"); and your subject (some subjects look better with darker edges, some with lighter edges). It is helpful to go to the Undo History panel and click back and forth between dark edges and no dark edges to see what the effect is really doing to your image. The Undo History panel is accessed through the Window menu.

Clone Effectively

Photos get stuff in them that do not belong with your subject. This could be as simple as dust on your sensor, which would show up as dark blobs in the sky. Or you could have a nice scene with a distracting bright spot in the background that you did not see when you took the photograph. Or perhaps there is an extraneous hand in the photo that is distracting. You can get rid of all these distractions by cloning with the Clone Stamp tool. Cloning simply copies part of a photograph from one place over another to cover an offending problem.

Clone Effectively

Set Up the Clone Stamp Tool

1 Select the **Clone Stamp** tool (📑), just below the middle of the Toolbox. It looks like a little stamp.

2 Select a soft-edged brush to help your cloning blend; use the brushes with the fuzzy edges shown in the sample brush in the options toolbar just below the menus.

3 From the toolbar at the top, select a brush size appropriate to the problem area you want to fix. You can see this because your cursor turns into a circle whose size represents the brush size.

Set Your Clone From Point

4 Magnify the area that you need to clone, using the **Zoom Magnifier** tool (🔍) at the top of the Toolbox.

5 Go back to the **Clone Stamp** tool (📑) and check the **Aligned** option in the toolbar. This aligns the clone from point with your actual cloning point as you do the work.

6 Press Option/Alt and click once to set a point that the cloning tool can clone from. This is the point from which the tool copies pixels.

Clone in Steps

7 Click to clone from the set point over your problem area.

8 Clone in steps; do not simply paint. Cloning in steps allows the cloning to blend better.

9 As you clone, change the clone from point whenever you start seeing duplicating patterns. Changing that point as you go is good practice.

Change Your Brush Size

10 Change your brush size as you work to make the cloning blend better with the problem areas. This is very easy to do by using the brackets, 〔 and 〕, located to the right of ℗ on your keyboard. The 〔 makes the brush smaller; the 〕 makes it bigger. Clone over the already cloned area using a different-size brush if you start seeing problems.

I have heard that you have to be careful of cloning artifacts. What are they?
An *artifact* in a photo is something that is not in the original scene or subject, but gets into the photograph because of the technology or technique the photographer uses. A *cloning artifact* is a repeating pattern or texture caused by cloning that pattern or texture to a new place nearby. You avoid it by changing your clone from point and your brush size. Watch for such artifacts as you clone and immediately make those changes.

What Layers Are About

Layers are beyond the scope of this book, but you may have noticed that they are an important part of the Photoshop Elements interface. The Photoshop Elements interface includes a Layer menu as well as a Layers panel. Layers are worth learning at some point because they can make performing a lot of adjustments faster and more efficient. This section introduces you to what they are and how they can help you. Everything shown in this chapter and Chapter 11 can be done with layers. For example, cloning is more foolproof when done to a layer.

What Layers Are About

Layers Are like a Stack of Photos

Photographers often get intimidated by layers. However, layers become less intimidating if you think of them as photos stacked on top of each other.

① The Layers panel shows that stack from the side, and just like a real stack, you can move layers up and down, remove them, and cut them into pieces.

Layers Isolate Adjustments

① Do whatever you want to a layer.

● Your changes affect nothing else in the photo.

If you use selections with a layer, you can really isolate an adjustment so that you affect only one thing and nothing else.

Adjustment Layers Are Nondestructive

1 Adjustment layers go over your photo and use the same controls shown in Chapter 11, but they act like filters that go over a print.

2 Adjustment layers change the look of your image.

● The original image is not altered, and so no pixels are damaged.

Layers Work Best Step by Step

As you add layers, follow the same steps that you have seen in this book, one adjustment at a time, as follows:

1 Use Levels for adjusting the blacks and whites.

2 Use the middle slider in Levels for midtones, because Color Curves is not an adjustment layer.

3 Use Hue/Saturation for color.

4 Rename each layer with a descriptive name. This allows you to quickly understand what your layers are doing to the photograph.

Simplify It

Can all these layers be saved with a photo and be worked on again if I reopen a photo?
That is another great advantage of layers: You can save them with your image file. Use Save As to save your photo as a Photoshop (PSD) file. This automatically keeps your layers when you save your image. Saving layers to a TIFF file is not a good idea because it makes that TIFF file less usable. Only Adobe products recognize layered TIFF files, yet a TIFF file is a ubiquitous format that any program that uses photos recognizes. If you want to save your photo as a TIFF file, flatten it first by using the Flatten Image command found in the Layer menu.

Chapter 13

Printing Photos

Photographic prints have long been a great way of sharing not only your photographs, but also your experiences, your trips, your family, and so many other parts of your life. A good print is fun and a joy to have. A bad print is disappointing and sad.

This chapter gives you some ideas on how you can consistently get better prints from your photographs. Printing is a craft. This means that really getting good at it takes some practice.

Start with a Good Photo for a Good Print

Often you hear people say that they do not have to worry about digital photography because they can fix their photos in Photoshop or Photoshop Elements. Stay away from that line of thinking! That gets you into trouble and prevents you from getting the best prints possible. Fixing images that were not shot properly from the start can be a frustrating and time-consuming process. In the end, the image is of less quality, and is usually difficult to print.

Blurry Photos Get Noticed with Larger Prints

Sharp photos make a difference. You can actually get away with a slightly blurry photo if the print is small. But if you want a large print, or if you want to crop a part of a photo and print it larger, you will really see that blur. A larger image also makes the blur larger for everyone to see.

Washed-Out Exposures Look Bad in a Print

When a part of a photo is washed out from overexposure, the white of the printing paper shows through the photo. This really adds empty detail to the picture. Most of the time, this becomes a distracting part of a print, which is not something you want. Avoid this with proper exposure.

Dark Exposures Increase Subject Contrast

Digital cameras are capable of capturing subtle, attractive gradations of tone in everything from the gentle tones of a green landscape to skin tones on a person's face. When you correct an underexposed image, you are working with less tonal range than the sensor is capable of handling, so the contrast of the subject can become unattractive.

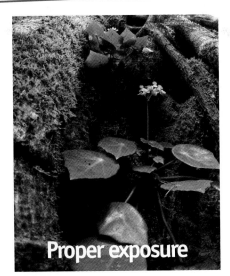
Proper exposure

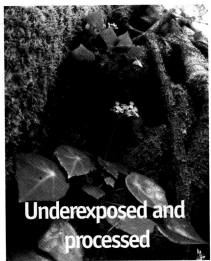
Underexposed and processed

Dark Exposures Cause Color Problems

Another problem with photos that are too dark is that as you brighten them in Photoshop Elements, you can have problems with colors. Color is recorded best in the middle range of what the camera's sensor can capture. As colors get dark, the sensor records less color, so even if you brighten the image, you have less color to work with.

Calibrate
the Monitor

If you want to make the most of your computer and digital photography all the way to a good print, consider calibrating your monitor. Monitor calibration does not guarantee a good print, but it gives you a consistent, predictable work environment that you can use more effectively to get a good print. Monitor calibration used to be complicated and expensive. That is not true anymore. Very affordable devices are available that work with automated wizards, making the process very easy.

Calibration Tools Start the Process

Monitor calibration needs a set of calibration tools. These come in a package that includes a sensor or "puck" that sits on your monitor to read it, and software to automate the whole process. You can easily share these tools with friends and other photographers, because you will probably calibrate only every few months.

The Puck Goes on the Monitor

The calibration sensor is often called a puck because it looks like one. It sits on your monitor over a location defined by the software. The software also tells you to do a few simple things with your monitor controls before you start using the puck to read specific colors.

Software Automates the Work

Once everything is set up, you tell the software and sensor to start working. The software sends carefully chosen colors to the monitor under the puck, and the sensor examines them. Then the software compares the information it has received to its database of what colors should look like.

A Profile Is Created

The program then creates a profile for your monitor. The profile adjusts how the computer and monitor interpret color so that colors are predictable and consistent. This way, you know that a better correlation will exist between the colors on your monitor and the colors in your print.

Using Photo Printers with Photoshop Elements

Today, almost all inkjet printers are capable of high-quality photo prints. However, a true photo printer can offer you the absolute best in print quality. Photo printers typically have more ink colors and finer ink dot sizes to create the best color and tonal gradations in a print. In addition, these printers have their software and hardware optimized for the print so that photos are the star of their performance. Many photographers have two printers, a small one for printing text quickly and a larger photo printer.

Using Photo Printers with Photoshop Elements

Set Photoshop Elements to Print

You have to tell Photoshop Elements how to send your photo to the printer so that colors are interpreted correctly.

① Click **File**.

② Click **Print**.

Note: *A quick and easy keyboard command to remember for this is* ⌘/Ctrl + P.

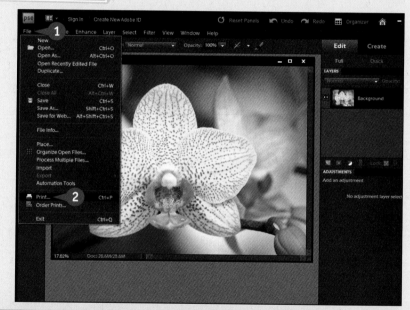

Check Your Photo Orientation and Size

The Print dialog box opens.

③ Check to see if the photo is oriented wrong or the wrong size by looking at the preview.

④ Change the orientation using these buttons.

⑤ Select your paper size with the Select Paper Size menu.

⑥ Select the size your image will print on the paper with the Select Print Size menu.

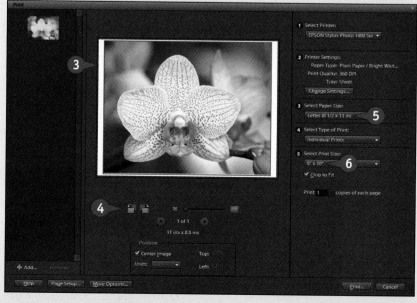

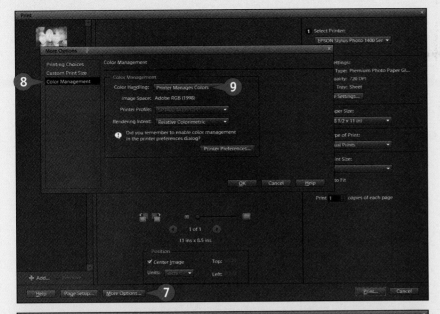

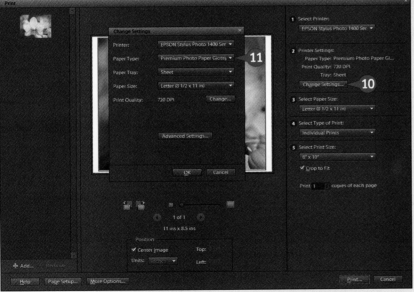

Tell Photoshop Elements How to Deal with Color

7 Click **More Options**.

8 Click **Color Management**.

9 Choose **Printer Manages Colors**. With most printers, this gives you excellent results.

Some printers give better results if Photoshop Elements manages color, another option in the Color Handling drop-down menu. Then you have to choose a printer profile that matches your paper type, as well as turn off color management in the printer driver software.

Tell Photoshop Elements What Paper You Are Using

10 On a PC, click **Change Settings** in Printer Settings.

The Change Settings dialog box opens.

11 Select the type of your paper in Paper Type.

On a Mac, click **Print** and the Print dialog box opens. Click **Print Settings** to choose paper.

Simplify It

What if I do not have a photo printer? Can I still make good photo prints?
All printers on the market today are capable of good photo prints. You may not have some of the capabilities that a true photo printer has, and prints might not be quite as good, but your printer is probably capable of very good-looking prints. The key is to choose the right paper and to set the printer driver correctly as described here and next in this chapter. Never use nonphoto paper for prints — often the glossy papers work best for standard inkjet printers.

Set the Printer Driver Correctly

Once Photoshop Elements is set to send your photo to the printer and you click Print, you go to your computer's operating system for printing. From there, you also access your printer's software controls, called the *printer driver*. The Windows and Mac operating systems display the printer controls differently. Different types of printers also have different interfaces in Windows. Regardless, you have to access the interface where you can change settings like the paper you are using or whether you are making borderless prints.

Set the Printer Driver Correctly

Open Your Printer Driver in Windows

1 In the Change Settings dialog box, click **Advanced Settings**. (This is not necessary on a Mac; however, you will need to set some of these options after clicking the **Print** button.)

Set Paper Choice and Quality

In Windows, the printer driver opens. This is the software that controls your printer, and each printer will have a different interface.

2 Choose **Photo** or **Best Photo**. You can test your results, but you will probably see little difference between these options.

Note: *Step 3 is very important. The printer has to know how to put ink down on the paper.*

3 Confirm your paper in the Type drop-down menu.

4 Click **Advanced**. This varies from printer to printer.

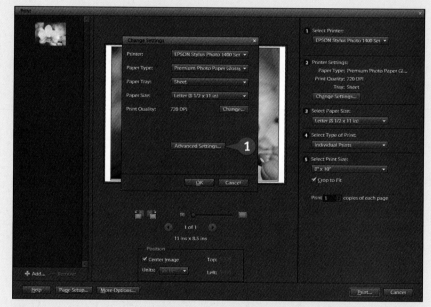

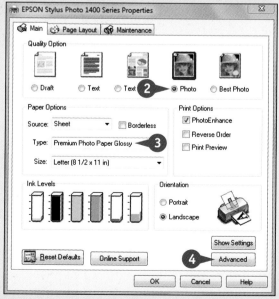

208

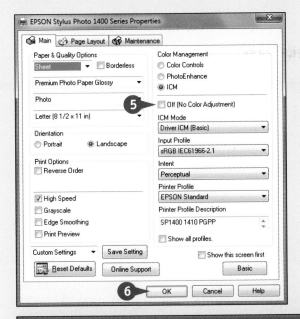

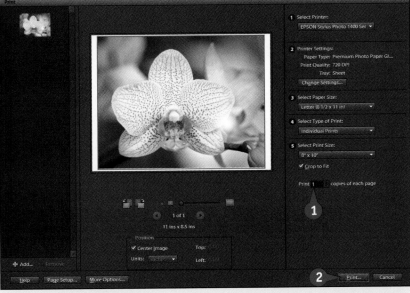

⑤ Find the Off or No Color Management or No Color Adjustment control.

If you chose to have Photoshop Elements manage color, then this option must be checked to turn off the printer's color management. If you chose the printer to manage color, then this should not be checked (usually the default).

⑥ Click **OK** and then **OK** again in the Change Settings dialog box.

Tell Photoshop Elements to Print

① In the Photoshop Elements Print dialog box, choose how many copies to print.

② Click **Print**.

On a Mac, the Print dialog box opens. You can choose the controls noted for Windows by going to the Print Settings and Color Management menus.

Simplify It

Printing inks can be expensive. How can I save money on inks?
First, do not use printer resolutions higher than 2880 dpi. That does little except use ink. Second, if the print is not looking good as it comes from the printer, press the Stop button on the printer to stop the printing process. Third, if you have problems making a print look good, print a smaller version as you make corrections. Fourth, try a test strip as described later in the chapter. Finally, buying off-brand inks can be cheaper, but be sure they are photo inks designed to match the manufacturer's inks.

Make the Right Paper Choice

To get the best photo print, you need to use the right photo paper. You are always safe with the manufacturers' papers for their printers, though you may find that some independent brands give you a look and a feel that you like.

Be wary of cheap photo papers. Getting the best colors from these papers can be difficult, and they usually do not have the best archival life. Photo paper is available in a wealth of choices — pick what fits your needs.

Choose Paper for Its Surface

Photo papers have surface finishes that range from matte to glossy. Glossy papers have the richest colors and sharpest details, but they have shorter lives and reflect glare. Matte papers have long lives, do not reflect glare, and today give much sharper details than before. The color is also very good, but different from that of glossy paper. You can get other surface finishes in between these.

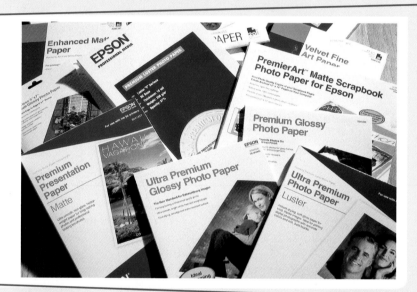

Select Paper for Its Weight

Paper has a weight. If your photo will be framed and behind glass, then weight has little bearing. But if you or anyone else handles the prints, then they need some weight for durability. People also like the feel of a heavier print. Many fine art photographers believe the heavier print is more appealing to clients.

RC Base
Thickness: 10 mil
Weight: 250 g/m²
Opacity: 97%

Look for Paper with the Right Whiteness

Photo papers, like all printing papers, have different degrees of whiteness. If you are working with glossy or semi-gloss and similar papers, look for the whitest paper possible. With fine art papers, the degree of whiteness needed is very subjective, and many photographers believe that it affects how a viewer perceives the print.

Printing Paper Choice Is Very Subjective

There is no such thing as the best photo paper, only a best paper for you. Some photographers love glossy paper, for example, and others hate it. In addition, some subjects look better with one paper, whereas others look better with another, and so you have to try out some different papers to find what works best for you.

Make a Good Print

Ansel Adams had a lot to say about printing in his classic books about photography. Printing was a key part of the photo process for him. Getting a good print is really a craft. It is not simply a matter of pushing the right buttons because ultimately the best print is still very subjective. Good printing is a skill honed by making prints and learning what your printer can really do, as well as discovering the quirks and nuances of your digital system.

Make a Good Print

Can You Match the Monitor?

Many people feel that if the print matches the monitor, they have a good print. There are several problems with this. First, a monitor displays colors in an entirely different way than a print. Second, people have quite a different psychological response to both media. Third, a print must stand on its own because few viewers ever see the monitor.

Consider Your First Print a Work Print

You do need a predictable workspace so that your monitor and print look close. However, take your print away from the monitor into good light and really look at it. Could it be better? Could it be lighter or darker? Do colors need to be adjusted? Is there a color cast? Go back to the computer and make adjustments based on this work print.

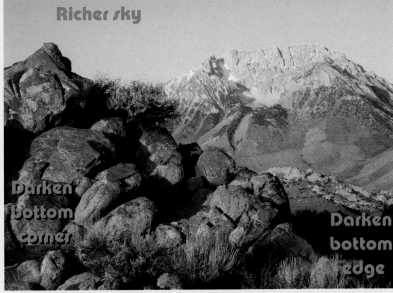

Create a Test Strip for Printing

1 Use the **Rectangular Marquee** selection tool (▦) to select a thin strip through the important parts of your photo.

2 Copy this selection by pressing ⌘/Ctrl + C.

3 Click **File**.

4 Click **New**.

5 Click **Image from Clipboard**.

● This creates a new photo based on your selected strip. Print this test strip photo to keep print time shorter and costs down.

Use Adjustments That You Know in Photoshop Elements

Use the adjustments you have learned in Photoshop Elements to improve the look of your print. It can help to write on your work print what needs to be done. Often you need to use selections to affect the color or tone of very specific areas that look okay on the monitor, but do not look good in the print.

Simplify It

How many work prints do I need to make before I get a final print?
You might get a perfect print for your needs from the first print or it might take several. The concept of a work print is simply to give you the chance to evaluate your print as a print, not an automated process controlled by the computer. Ansel Adams always made work prints, sometimes many. For him, that took a long time because of the processing needed in the darkroom. But the digital photographer can try an adjustment and make a new print in minutes. This can also help you learn to make better prints in the future.

Add Text to a Print

There are many reasons for adding text to a print. You might want to include information about your subject or create a poster or flyer. Text is also useful for making a greeting card that you can print directly on your photo printer. If you want to print a lot of text, such as in a newsletter, you need a design program. But for short bits of text on a print, Photoshop Elements works very well.

Add Text to a Print

Find the Text Tool

1 Click and hold the **Text** tool (**T**) to display four text tools that you can choose from.

2 Click a text tool. The horizontal and vertical tools are the easiest to use and the best place to start.

Set Up the Text Tool

The Text tool acts like any word processor. You have to tell it what font to use, the size, and so on.

3 Change these settings in the toolbar above the photo work area. You can choose the font, its weight, size, spacing, alignment, and so on. You can also change these settings later.

4 Choose a color by clicking the color box.

Click and Type

⑤ Click the photo wherever you want the text, and start typing.

If necessary, edit the text using the controls in the toolbar at the top. First select the text by clicking and dragging over it.

Move Your Text

⑥ Move your text as you type by clicking outside of the text area until your cursor changes to a double-headed arrow. Then click and drag the text to where you want it.

● You can also move your text at any time by clicking the **Move** tool (🔀) at the top of the Toolbox and clicking the layer with the text. Text is added to a photo as a layer so that you can move it easily.

Simplify It

When I am done with adding text, what should I do with that text layer?
One advantage of a text layer is that you can change it whenever you want. Just double-click the text icon in the Layers panel to highlight the text, and then type something new. You can save this text layer with your file if you save as a PSD file. If you want to save this file as a locked file with the text embedded into the image, you can flatten the image using the Flatten command in the Layer menu, then save as a TIFF file. If you save as a JPEG file, the layer is automatically merged into the photo.

Chapter 14

Basic Video Editing with Premiere Elements

Video is now built into most digital cameras. This added feature can be a lot of fun, but it can also be a challenge because once you shoot your video, you have to edit it. Video is made up of a workflow that is based on a series of shots that, put together, tell a story or present information about something that you have recorded.

This chapter gives you some ideas on how you can start editing your videos. Premiere Elements is a good program for editing video, but like most programs, you need to work with it to learn how to get the most from it.

Review Your Shots

To get started working with your video, you need to look at everything you shot. In the video editing world, each shot is called a *clip*. You need to have an idea of what you actually have on those clips, such as what sorts of action are on them, but to do that, you have to transfer your video to your computer. This process is the same as the one described in Chapter 10. Once they are on your computer, you can then start reviewing your shots.

Keep Your Videos in a Project Folder

You will be using your video files to create a program. This means you need to have a filing system for your hard drive that keeps all your videos for a certain project or shoot together. Do not separate your videos into different categories like you might for still photos. If they go together as a group, keep them together in a single folder.

Reviewing Videos on a Mac

A Mac makes it very easy for you to review your videos. Once they are in a folder, you simply click a video file and press Spacebar. The video automatically enlarges and starts playing. Do not double-click your file or it will launch a program to play your video. You can make notes as needed as you go through your folder of videos.

Reviewing Videos on a PC

On a PC, double-click video files to load them into a player. PCs come with Windows Media Player, which is usually the default for playing video. It works well, but do not close it when you finish with a clip. Pause the clip, go back to the folder, and then double-click a new video file to play. This loads the video faster without relaunching the player.

HD Video Can Have Playback Problems

HD video is pulling a great deal of data from your hard drive. If you have a slow hard drive, an older computer, or a limited-capacity laptop, you may find that the video does not play back smoothly — the video can stutter or lose audio. This does not mean your video is bad, simply that your computer might not be capable of handling full HD video.

Look for an Order to Shots

Video is about sequences of clips that come together to tell your viewer something special about your subject or scene. You can tell a story, create a video essay, or simply put a series of pretty video clips together with music. Regardless of the end use, your video needs a beginning, middle, and end. This is really a unique opportunity for you to work visually. Although you could do this sort of thing with a slide show, you now are adding movement and sound that can truly make your scene come alive for a viewer.

Take an Overview of Your Shots

As you go through your shots, try to get an idea of the range of clips you have. Pay attention to the variation in shots, the type of shots, the chronology of shots, and so on. Look for natural orders within your clips. Think about how someone might look at all these shots and what kind of order you would need to have it make sense.

Choose a Clip to Start

Although you might start your video with a title, you still need a first video clip to get the program going. Do not take this lightly. Look for a clip that can set the stage for your edited video. This could be something dramatic and eye catching, or it could be as simple as a wide shot that shows off a location. Which one to use depends on your purpose.

Select an Ending

You can end your video with a slide that simply says, "The End" but that is not enough for your viewers. They want to see a clip of video that satisfies their need for an ending. The ending clip can be something that shows an ending, such as a person heading away from the camera, or it can be a visual peak that builds from the clips before it.

Find an Order for the Rest

One way of putting together the rest of your clips is to do them chronologically, such as telling a story of an event from beginning to end. Or create an essay of visuals that go together visually. Look to go from clip to clip in ways that make visual sense, such as dramatically contrasting a wide shot with a close-up or gently changing the variation of shots by keeping colors and light consistent.

Edit Clip Length

Now you need to start putting your clips together. Although you could have started this process in Premiere Elements, it can be easier to go through your clips directly from your hard drive. Once you have reviewed your clips and have a rough order, you can then import them into Premiere Elements for the actual edit. Once the clips are imported, you must place the clips in order on the timeline or sceneline, but first, you need to edit a clip to the right length, removing unneeded video from the beginning and ending of each clip. This editing is nondestructive and does not affect your original.

Edit Clip Length

Import Your Video into Premiere Elements

Importing video files from your hard drive is like opening any computer file.

1 Click **Get Media**.

2 Click **Files and Folders**.

3 From the standard file-opening dialog box that appears, go to your project folder and select all of the videos in it by using your computer's list view then clicking the first file and
Shift + clicking the last one.

4 Click **Open** (**Import** on a Mac).

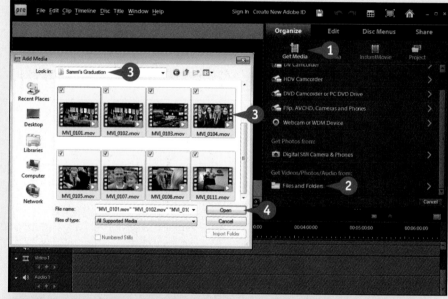

Open the Preview

● Your video files open into Premiere Elements.

1 Double-click a video file.

● The preview opens.

2 Resize the dialog box by clicking and dragging the sides or corners on a PC, the bottom right corner on a Mac.

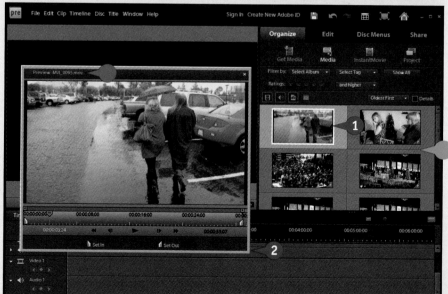

Find the In Point

③ Click the **Play** button (▶) to find a starting place.

④ Press `Spacebar` to stop playback. You can also press `Spacebar` to start play.

⑤ Click and drag the timeline marker (▽) to find a place to start the clip, called the *in point*.

● You can also click the **Set In** button (▮) when your cursor is at the right spot to start the clip.

Find the Out Point

⑥ Click the **Play** button (▶) to find an ending place.

⑦ Press `Spacebar` to stop playback.

⑧ Click and drag the timeline marker (▽) to find a place to end the clip, called the *out point*.

● You can also click the **Set Out** button (▮) when your cursor is at the right spot to end the clip.

Your video clip is edited.

How can I speed up the process of setting in and out points?
Like all Adobe programs, Premiere Elements includes a lot of keyboard shortcuts that can make your work more efficient. When you are changing the clip length, you can quickly set the in and out points by playing the clip or moving the cursor and pressing I at the in point and O for the out point.

Place Clips in Timeline

As you edit your clips to length, drag them into the timeline or sceneline of your video. As you place your clips in an order there, your video will begin to take shape. Do not worry if your order is not exact right now. You can always click and drag clips from one place in the timeline or sceneline to another. You can go back and forth between timeline and sceneline. The timeline is based on time and makes it very easy to see how long your clips are and to adjust their lengths. The sceneline emphasizes scenes and makes it easier to see how your clips go together as visual elements.

Place Clips in Timeline

Choose Sceneline

1. Click **Sceneline**.

2. Click the clip in the preview and drag it onto the sceneline where it works best.

3. Continue adding clips from the Project part of Organizer.

 The sceneline puts together your clips as though you were assembling a slide show.

Select Timeline

1. Click **Timeline**.

2. Click the clip in the preview and drag onto the Video 1 track in an order where it works best.

3. Continue adding clips from the Project part of Organizer.

 The timeline puts together your clips as segments of time through your program.

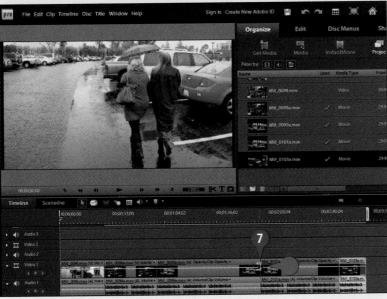

Change the Position of Clips

4 Click a clip in the timeline.

Note: Be careful that you do not click the orange line in the clip. If you click the orange line and try to drag the clip, the opacity of the clip is changed.

5 Drag it to a new location.

You can drag this clip into the same track as the rest of your clips, which will cause the timeline to open for it. Or you can drag a clip to a new track. Higher tracks always have priority in playback.

6 Click **Timeline** and choose **Render Work Area**.

● The red line above the timeline changes to green. This affects playback and final use.

Change the Length of a Clip

7 Position your cursor over the end or beginning of a clip in the timeline.

● The cursor changes to ⬌. The direction of the bracket tells you which clip you are working on when you are at an edit point between two clips.

8 Drag the cursor to change the length of the clip.

Simplify It

How can I see the clip timing better in the timeline?
You can zoom in on the timeline in order to see more detail. Use the slider just above the timeline on the right side of the screen. Space out the time to gain space to work with in a single clip, or use less spacing to see how entire clips relate to each other.

Add Titles to Your Video

Titles can add both a professional-looking touch and good information to your video. Premiere Elements includes a complete titling feature. You can add simple titles over video, you can create elaborate titles over a colored background, and you can even move your titles across or up and down the screen. Premiere Elements offers you the tools to create a title page from scratch where you choose everything from font to color or use lettering presets that give you interesting titles with just a click of the mouse. Whatever you do, keep titles short and easy to read for your viewer.

Add Titles to Your Video

Open Text Options

1 Move the timeline marker (⬇) to the position you want to place a title.

2 Click the **Text** button (**T**).

Text Options open.

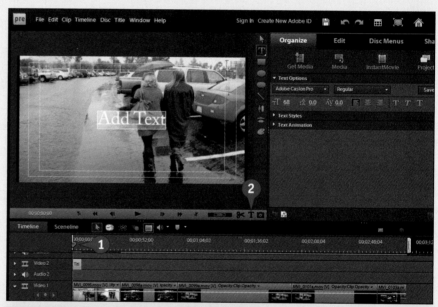

3 Type your text.

4 Change the text with standard text tools.

5 Click the **Selection** tool (▶) to position your text.

6 Click the beginning or end of the text on the timeline and drag to change its timing.

7 Click **Timeline** and choose **Render Work Area** to change the red line above the timeline to green.

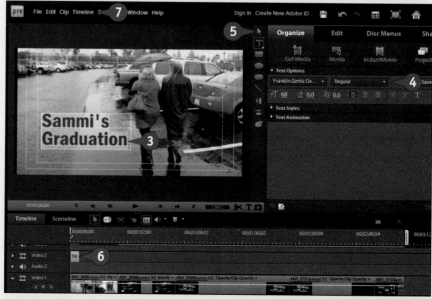

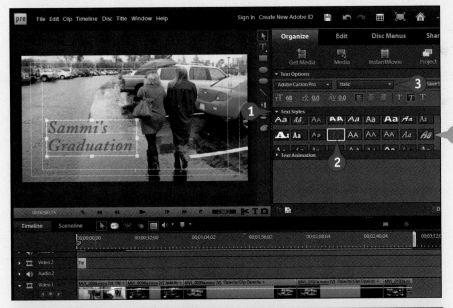

Use Text Styles

1 Click the Text Styles arrow.

● Different styles of text appear.

2 Double-click a style to use it with your title.

3 Change the text with standard text tools.

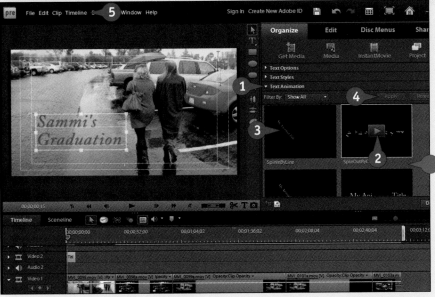

Animate Your Text

1 Click the Text Animation arrow.

● Different options for text animation appear.

2 Click the **Play** button (▶) that appears when you position your cursor over the icon to see a sample play.

3 Click an option to use it with your title.

4 Click **Apply**.

5 Click **Timeline** and choose **Render Work Area** to render the effect so it plays back when you play back the timeline.

Simplify It

What are the white lines in the text area?
The white lines creating boxes around the title area include the title-safe areas. This means that you need to keep your title within the smaller box if you plan to play your video on a television. If you are displaying only from a computer or online, you can ignore those boxes.

Adjust the Sound for Your Video

Sound or audio is a very important part of video. Premiere Elements offers a number of controls to help you adjust audio so that it sounds good for your viewers. Good audio can really make a difference as to how a viewer watches your video. It can help the visuals look their best because viewers connect sound and visuals as they watch. Bad audio can bring even good visuals down. As you play back your video, listen for sound problems, such as abrupt changes in volume, unpleasant sounds, or a background sound that is too loud.

Adjust the Sound for Your Video

Magnify the Timeline

1 Move the timeline marker (▽) over the video segment that you want to affect.

2 Click and drag the sizing icon at the top right of the timeline to magnify the timeline.

● Magnifying the timeline lets you see the audio patterns, which are called the *wave forms*. This helps you find places to change audio. This also gives you space to work.

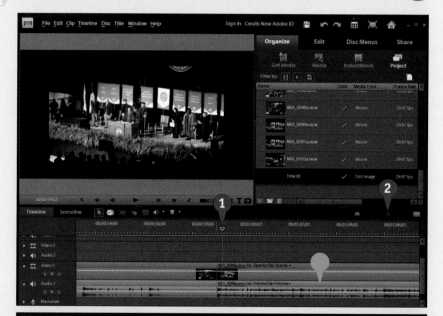

3 Click and drag the yellow line in the audio track to make the audio louder or softer — up for louder, down for softer.

● A notation appears showing you how much you are changing the volume or level of the sound.

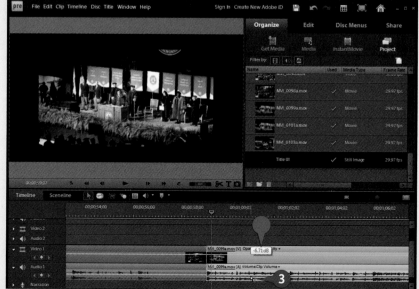

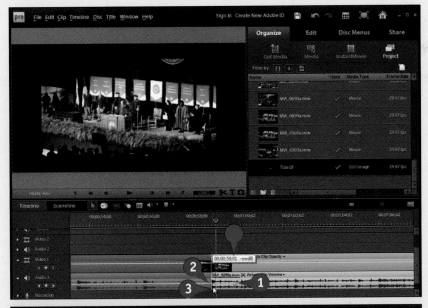

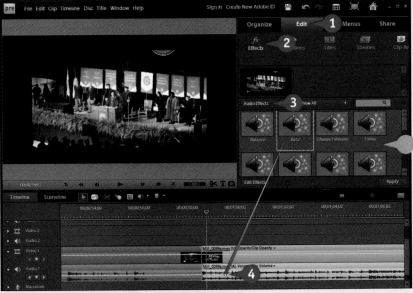

Adjust a Section of Audio Track

① ⌘/Ctrl + click the yellow audio line to set a marker called a *keyframe* some time in from the start of the clip.

② ⌘/Ctrl + click the yellow audio line where the clip starts to set a new keyframe there.

③ Drag the second marker down to the minimum.

● This creates a fade in of the sound for the clip.

Change any part of a clip by setting keyframes to limit where the audio change will occur.

Add Audio Effects

① Click **Edit**.

② Click **Effects**.

③ Choose **Audio Effects**.

● Different options for audio adjustments appear.

④ Click and drag an effect over the audio track in your timeline.

Simplify It

How can I get rid of bad audio?
If the sound from a clip is really bad, right-click the clip to get a contextual menu. Mac users should be using a right-click mouse for Adobe products, too. Find the entry Delete Audio and click it to remove the audio track. You can also click **Delete Video** to keep the audio and remove the video.

Add Special Effects to Your Video

Premiere Elements offers special effects that you can add to your video that just two decades ago would have required gear costing over $100,000! Create interesting openings and closings to your program by spinning the video through the frame. Add dramatic transitions as you go from one location to another by moving the video to push one location out as the other

comes in. You can also make adjustments to the appearance of your video including everything from brightening the image to creating a cartoon effect. Be careful as you use effects, however, so that they do not overwhelm the real reason for your video, the subject.

Add Special Effects to Your Video

Choose an Effect

1 Position the timeline marker (⬒) over the video segment that you want to affect.

2 Click **Edit**.

3 Click **Effects**.

4 Choose **Video Effects**.

● Different options for video effects appear.

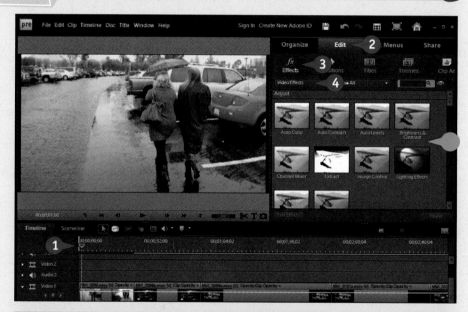

5 Click an effect.

6 Drag an effect over the displayed image or over the clip in the timeline.

7 You have to render the timeline before an effect plays properly by going to **Timeline** and choosing **Render Work Area**.

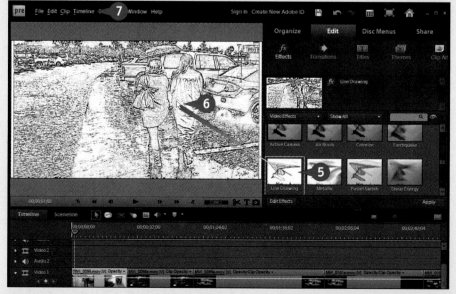

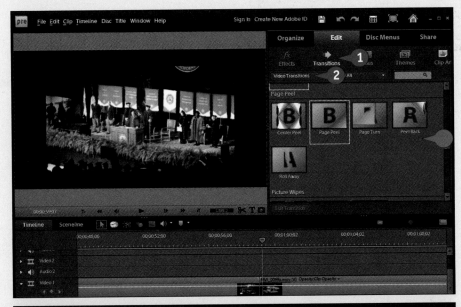

Use a Video Transition

1 Click **Transitions**.

2 Choose **Video Transitions**.

● Different options for video effects appear.

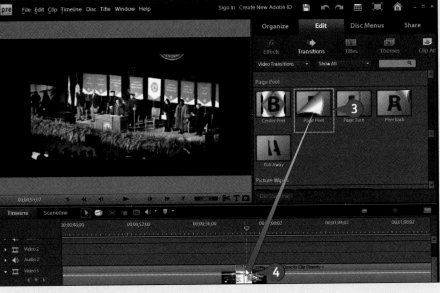

3 Click an effect.

A sample of the effect plays inside the effect icon.

4 Click and drag an effect to a juncture between two clips of audio on your timeline.

Simplify It

Can the duration of a transition effect be changed?
You can change the length of any transition so that it happens faster or slower to match the tempo of your video. Simply double-click the transition in either the timeline or sceneline and a set of options opens in the upper right side of the interface. Go to Duration and change the time to change the transition length. Remember video is usually 30 frames per second.

Add Music to Your Video

Music can be a wonderful addition to your video. It can cover up or even replace problem audio as well as create a mood for your visuals. If you are making the video only for family and friends, then you can use whatever music you want. However, if you plan to use your video for any business purposes, from showing customers to training employees to encouraging salespeople, or if you plan to show video at any paid event, you cannot use most music without permission. You can find royalty-free music by searching on the web.

Add Music to Your Video

Import Your Audio into Premiere Elements

Importing audio files from your hard drive is like opening any computer file.

1 Click **Get Media**.

2 Click **Files and Folders**.

3 From the standard file-opening dialog box that appears, go to your music folder and click the music you want to use.

4 Click **Open** (or **Import** on a Mac).

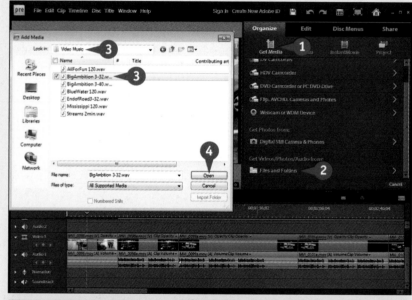

5 Click the imported music file.

6 Drag the music to the Soundtrack in the timeline.

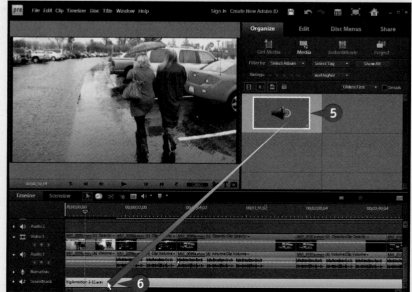

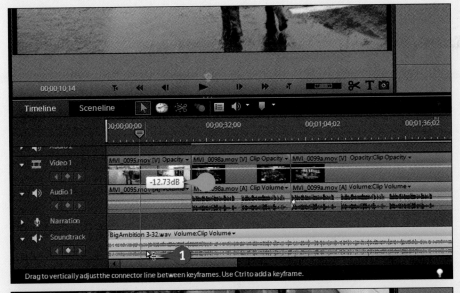

Adjust the Volume of Your Music

① Click and drag the yellow line in the Soundtrack to make the music louder or softer — up for louder, down for softer.

● A notation appears showing you how much you are changing the volume or level of the music.

Fade In Your Music

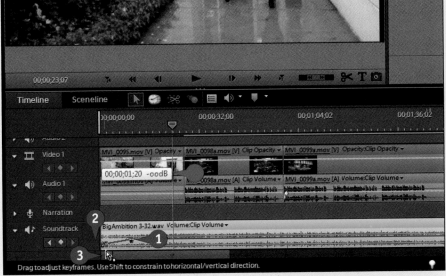

① ⌘/Ctrl + click the yellow audio line to set a marker, or *keyframe*, some time in from the start of the music to set a marker.

② ⌘/Ctrl + click the yellow audio line where the music starts to set a new keyframe there.

③ Drag the second marker down to the bottom of the track box.

● This creates a fade in of the music.

Fade out the music at the end of your video using the same technique based on where the video ends.

Where can I get music?
One way to work with music is to use royalty-free music. You can find royalty-free music by searching on the web or by using programs like SmartSound at www.smartsound.com. SmartSound uses a program to build music to a specific length, which is very useful when editing video.

233

Export Your Edited Video

Once you have edited your video, you can share it with others. Premiere Elements makes this very easy to do in its Share section. You can burn a DVD from your video that can be played on your DVD player and television. That can be standard definition DVD or HD video on Blu-ray media. You can share your video directly to online video sharing sites such as YouTube, or you can create a video that can be played on your mobile phone. Premiere Elements offers simple options to help you get your video ready to play on almost any media player.

Export Your Edited Video

Start Sharing Your Video

1 Click **Share**.

● A whole range of possibilities for video sharing becomes available.

2 Click an appropriate type of output for your needs.

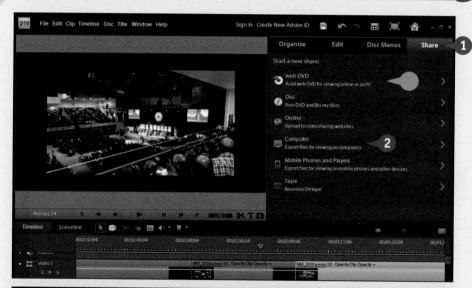

Options for your choice appear, such as sharing a file for computer use.

3 Click an option.

● Specific presets appear.

4 Type a name for your video.

5 Select a location to save the video.

6 Click **Save**.

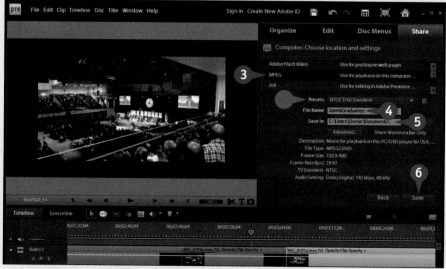

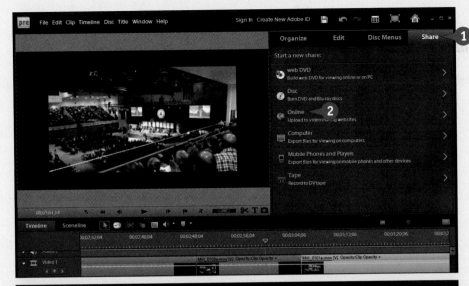

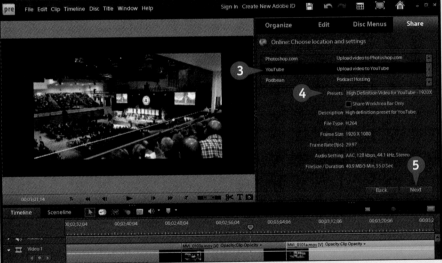

Share Your Video on YouTube

To upload to YouTube, you have to set up a YouTube account at www.youtube.com. Just follow the instructions on that site.

1 Click **Share**.

2 Click **Online**.

The online options appear.

3 Select **YouTube**.

4 Choose the video preset needed for the type of video you want to upload.

5 Click **Next**.

Put in the information about your YouTube account, including user name and password, so that Premiere Elements can prepare your file and upload it to the YouTube site.

Why does my uploaded file look so bad?
Some sharing sites recompress your file in order to offer different resolutions to their visitors. This recompression takes time. In the interim, the site may put up a lower resolution file. If you are concerned about the quality of the movie you uploaded come back to the site after an hour or so to see if the quality improves.

Index

Index

Index

Index

Index